KITCHENER PUBLIC LIBRARY

W9-DFU-455

-2

ONTARIO BEER

ONTARIO BEER

BEER

A HEADY HISTORY OF
BREWING FROM THE GREAT LAKES
TO HUDSON BAY

ALAN McLEOD & JORDAN ST. JOHN

Charleston · London

THE
History
PRESS

Published by The History Press
Charleston, SC 29403
www.historypress.net

Copyright © 2014 by Alan McLeod and Jordan St. John
All rights reserved

Cover images: Grenville Brewery courtesy of Library and Archives Canada, Acc. No. 1977-18-60, Molson Portrait Collection, Molson Archives, Montreal, Quebec; image of falls courtesy of Artur Staszewski, Flickr.

First published 2014

Printed in Canada

ISBN 978.1.62619.256.0

Library of Congress CIP data applied for.

Notice: The information in this book is true and complete to the best of our knowledge. It is offered without guarantee on the part of the authors or The History Press. The authors and The History Press disclaim all liability in connection with the use of this book.

All rights reserved. No part of this book may be reproduced or transmitted in any form whatsoever without prior written permission from the publisher except in the case of brief quotations embodied in critical articles and reviews.

CONTENTS

ACKNOWLEDGEMENTS

The authors thank their family and friends who have either come to share their joint obsessions with beer and history or supported the project with patience.

The authors thank the helpful staff of the libraries and archives they have relied on, in particular the staff of the National Library and Archives and the staff of Molson Coors Canada for their assistance in the review of the Molson corporate archives. The authors are grateful for the work of those who have created web-based archives of newspapers throughout Ontario, such as the *Kingston Gazette* or the *Essex Free Press*, from the 1790s to the present day. They have gained a deeper admiration for the authors who preceded them who were not able to access these resources as easily. The authors are also grateful for the work of other writers who have taken on the topic of beer in Ontario, including Ian Bowering, Ian Coutts, Steve Gates and Craig Heron, as well as historians Jane Errington and Brian Osborne.

The authors also thank the many craft brewers of Ontario who took the time to discuss and support the research required as part of this project—in particular, Steve Beauchesne of Beau's All Natural Brewing Company in Van Kleek Hill and John Graham of Church-Key Brewing in Campbellford. They also thank those who sell the province's good beer in the pubs and restaurants where they have brooded separately or argued with each other.

INTRODUCTION

W riting any history of Ontario poses a particular problem. Without a defining foundational event like the victories of Lexington and Concord or the conquest of the Plains of Abraham, Canada's largest province can appear to lack a single foothold on which to base understanding. Ontario as we know it today began as a planned society—a Georgian British ideal. The first street grids of cities like Kingston and Toronto were laid out before the people arrived. The orderly surveys that created the grid of the generous concession lots in the countryside were mainly drawn before the farming families were settled and their plows broke the earth. Established to serve as an ideal society based on a particular mix of conservative and progressive values, the communities of Ontario succeeded in large part because of where they were located, whether at a river's mouth or near rich farmlands, as much as due to any political theory.

The history of brewing in Ontario goes farther back and both illustrates and serves as a guide to the growth of the province's society. As a functional necessity, beer and other forms of alcohol were present when the first explorers came to the region, followed by European empires seeking to control the export of furs and pelts while attacking the trade routes of their competition. Even before the conflicts of the eighteenth century among the British, French, Dutch, American and First Nations, the indigenous peoples of Ontario were in contact with the French empire from the expedition of Jacques Cartier up the Ottawa Valley. The Jesuit missions in the first decades of the 1600s in the south of Ontario, as well as the first forts and factories of

the Hudson Bay Company in the north by the 1670s, were reaching out and seeking alliances with the First Nations.

Brewing was a part of the history of European settlement because beer was a normal part of the European diet. Just as explorers and traders in the 1600s brought casks of beer and barrels of malt to ensure supply, breweries were planned and built starting in the late 1700s in the river mouth towns, where the grains from inland farms were brought by mercantile interests for shipment out to the empire just as furs and pelt had been from the early 1600s. These breweries were built under government authority to supply the military that protected the young colony from the expansionist pressures and new democratic ideas developing to the south in the newly independent United States.

As communities strengthened throughout the Victorian era, government-licensed taverns that served as pioneer community centres were replaced by private inns and supplied by private breweries serving the commercial interests of their owners. As industry expanded and the borders of Canada moved west and north, Ontario's brewing industry expanded and consolidated into the large industrial scale recognized today. In the final third of the twentieth century, home-brewing, brew-on-premises and craft brewing, as well as "buck a beer" discount brewing, represent reactions to mega industrial beer as Ontario's economy responds to greater demand for consumer choice. They also represent some level of reaction against Ontario's traditional trust in a centrally administered, well-regulated society that both protected established interests and distributed wealth widely.

In many ways, the history of beer in Ontario is the history of Ontario. As a daily part of the diet to an industrial product that took its place in the national and international marketplace, the laws and cultural norms of Ontario throughout its history can be understood by their relation to beer.

CHAPTER 1

EXPLORATION AND EMPIRES

1600s–1775

The first two centuries of European contact from the early 1600s to the late 1700s within the lands that would come to be known as Ontario were marked by explorations undertaken for a mix of commercial, religious and political goals. Colonization of the region was not within the practical plans or resources of either the French or English (then British) empires. Ontario was populated by a number of First Nations who provided the Europeans with military and trade alliances. They also vastly outnumbered any local European population. There was little incentive to create towns in the interior of the continent much beyond the inland reach of the salt waters of the Atlantic. However, over the course of this period, brewing would be present in ways that illustrated the interests of each culture. The functional role that beer played in their societies would prove similarly distinctive.

THE DEATH OF HENRY HUDSON

The first drink of beer in or near what is now Ontario might be the most notorious; it was certainly among the most wicked. In 1610, Henry Hudson was on his fourth voyage of exploration after having charted the mid-Atlantic shore of what is now the United States on behalf of the Dutch; Hudson was engaged by the British to seek a route to Asia. Passing Greenland on June

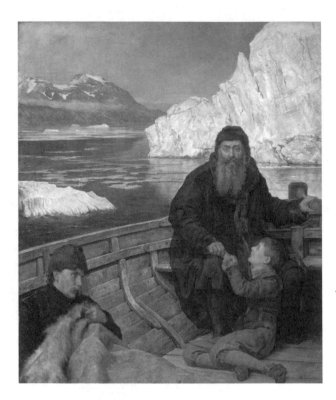

John Collier's representation of Henry Hudson's ultimate fate in the longboat following the mutiny. Ironically, Hudson has the look of a man who could really use a beer. *Courtesy Google Art Project.*

4, 1610, he guided his ship *Discovery* first west and then, on August 2, veered south hundreds of miles into what would be named Hudson Bay.

Hudson and his crew explored, moving south along the bay. They became icebound near Ontario's shore in James Bay, where the *Discovery* spent the winter. In the new year, as Hudson continued his exploration, the crew mutinied, fearing that their captain was putting them all at deadly risk. The crew set to ripping apart the ship's supplies. The scene was later recounted in 1625 by one sailor who was present and survived:

> [T]*here were some of them that plyed their worke, as if the Ship had been entred by force, and they had free leaue to pillage, breaking vp Chests, and rifling all places…In the Hold they found one of the vessels of meale whole, and the other halfe spent, for wee had but two; wee found also two firkins of Butter, some twentie seuen piece of Porke, halfe a bushell of Pease, but in the Masters Cabbin we found two hundred of bisket Cakes, a pecke of Meale, of Beere to the quantitie of a Butt, one with another.*

The mutineers gorged themselves, drinking to the death of their hated captain with his own strong ale as Hudson, along with his son and several loyal crew members, was set adrift in a small boat, left to their deaths on frigid coastal waters. The *Discovery* immediately turned north for home. Despite the evidence, no one was found guilty of Hudson's death. The circumstances might have been too strange and too distant from the court for them to make a finding beyond any reasonable doubt. Ontario's far-flung Arctic coast at that time was as foreign to Europeans as the surface of Mars. In a few decades, however, the English would establish a trading empire in Ontario's north that continues today. At the trading posts of the Hudson Bay Company, some of Ontario's earliest breweries were established.

BREWING IN EARLY NEW FRANCE

To the south, at about the time of Hudson's death, another European empire was establishing itself and bringing with it its own traditions of brewing beer and making other strong drink. New France was founded in an effort to control the interior of North America via the St. Lawrence Valley and the eastern Great Lakes, just as England sought access through Hudson Bay. The southern portions of Ontario would be under the influence of New France for more than a century and a half.

It is clear that French explorers and missionaries brought alcohol with them on their travels. Drinking provisions for their voyages included cider and brandy as they sailed west from Europe. Recollet friar Gabriel Sagard complained of not being able to handle strong drink while seasick on the Grand Banks in 1623 on his voyage to preach the gospel to the Huron people of Central Ontario. He centered his missionary work at Ossossanë, about thirty miles west of the modern city of Orillia.

As New France expanded after the establishment of its main settlement by Champlain at Quebec City in 1608, Eastern and Central Ontario provided key travel routes for both the fur trade and missionary work. Beer came to New France in the 1630s (at the latest) with Jesuit priests who brewed as part of their daily duties. A brewing kettle is noted as being used for a feast hosted by Samuel de Champlain with the Huron nation in 1632. By 1634, a full brewery was being planned.

The role of beer is illustrated in the 1636 Jesuit records of New France. In these reports sent back to the order's central administration in France, the life, work and needs of the young agricultural community are described:

> *Twenty men will clear in one year thirty arpents of land, so clean that the plow can pass through it; if they had an interest in the matter, perhaps they would do more…As rations, each one is given two loaves of bread, of about six or seven pounds, a week—that is, a puncheon of flour a year; two pounds of lard, two ounces of butter, a little measure of oil and of vinegar; a little dried codfish, that is, about a pound; a bowlful of peas, which is about a chopine [pint]—and all this for one week. As to their drinks, they are given a chopine of cider per day, or a quart of beer, and occasionally a drink of wine, as on great fête-days. In the winter they are given a drop of brandy in the morning, if one has any.*

In the years that followed, skilled brewing became established in the colony. In 1646, the Jesuit records stated that one Brother Ambroise was "employed, from the 1st of May till the 20th, in preparing barley at notre dame des Anges, and the beer." Later in the 1600s, two seigneurial grants were established in what is now Ontario at Hawkesbury and Kingston. The plan was less to expand agricultural production as it was to drive the interests of the French empire deeper into the continent in its search for furs and souls.

One small farming estate at Kingston was located to the west of Fort Frontenac in the 1680s. It was owned and farmed by Madeleine de Roybon d'Allonne and her tenants. She is considered the first European woman to own land in Ontario and was directly involved with First Nations trading, as well as improvements to her farmlands. It is tempting to speculate that these first farming Ontarians were brewing their own beer. It is likely unreasonable to assume they did without.

BEER AND BREWING ON HUDSON BAY IN THE LATE 1600s

Conflict between these empires was inevitable. The conflict for control of Ontario from the later 1600s was primarily between France and England. The Dutch colony in what is now Central New York on the Hudson River

sought its share through its alliance with the Mohawk nation until the 1660s, when it came under English control. England continued to expand its trading empire on Hudson Bay and James Bay through the establishment of factories in the 1660s and 1670s. Beer was consistently included in the ships' stores for the voyages, and unlike the French, apparently, so was the means to brew beer as soon as the ship made shore. An order placed by the Hudson Bay Company's London management for three grades of beer, as well as malt and hops, was recorded in the minutes for 1672: "John Raymond, 'By Severall quantityes of Ship Beere at 40s p. Tonn Strong beere at 12s, 9d a barrel & Harbor Beere at 6s 6d p. barrell with Malt & Hopps dd. Capt. Gillam, Morris and Cole,' £79."

A few years later, on July 6, 1674, the committee of the Hudson Bay Company directed payment to the same John Raymond of thirty pounds on account of "Beer and Malt. dd. on board the Prince Rupert." The three grades of beer supplied and the means for crews to brew their own beer once the ships made landfall illustrate the various functions that beer played in the life of the company. Ship beer, the cheapest and weakest, would have served as daily drink for the crew while at sea. The strong beer might have been reserved for the officers, as was apparently the case on Hudson's voyage. Harbour beer might have been a middle-strength beer for when the ship was at anchor. The early ships' crews considered their beer of great importance and even instrumental to survival. In 1668–69, the crew of the *Nonesuch* overwintered on the James Bay coast and reported upon their return: "They were environed with ice about 6 monethes first haleing theire ketch on shore, and building them a house. They carried provisions on shore and brewd Ale and beere and provided against the cold which was their work."

Note the reference to the two separate forms of fermented drink. Ale was likely unhopped or lightly hopped and brewed for early drinking, while beer would have been hopped likely for longer keeping. Another crew had to stay over in the winter of 1674–75 but were better prepared and provisioned for this possibility: "It was now too late in the season for the ships to return to England so arrangements were made for them to over winter in Rupert River and the crews were employed to cut Timber, to build Houses for them, as also a Brew-House and a Bake-House in the Fort."

Their planning was not always successful. The beer and "winter-liquor" reportedly ran out by April 1674 at one Hudson's Bay fort, even if the stores of beer and malt shipped with the crews were significant. In 1674, the Hudson Bay Company planned three quarts of beer a day per man and shipped enough beer and malt to supply the trip there and back, as well as to

survive a winter. Twenty-seven tons of beer and fifty-nine quarters of malt were purchased in April 1674 for that season's sailing of the thirty-two-man expedition. That would total roughly eighteen thousand pounds of malt, or enough malt to provide each man with one pound per day.

Clashes between the empires required feats of unimaginable hardship and daring. When forces from New France struck at the forts on Hudson Bay in 1686, its soldiers walked north overland from the St. Lawrence Valley through hundreds of miles of forest before attacking and capturing Hudson Bay forts, including Moose Factory at the mouth of the Moose River. The return trip by foot took four months just to reach the northern community at Temiskaming in December. The French detachment survived on five or six pounds of pork per man, as well as sprouted barley that had been "intended originally for brewing beer." The French, now victors in this phase of Europe's war for the New World's north, survived the march home through the primeval winter forest by eating the brewing malt of the defeated English.

SPRUCE BEER AND THE BATTLES IN THE MID-1700s

A few decades after these northern clashes, the record of French provisions at Fort Frontenac in Kingston indicates that the fort existed as a supplied outpost of the larger centres of Montreal and Quebec down the St. Lawrence River. It was more dependent than the self-contained communities that the Hudson's Bay Company sought to establish on the northern coast. The fort subsisted on barrels of flour and bread sent upriver in supply bateaux rather than locally harvested grain or freshly baked goods. Similarly, there are a number of barrels of wine and even more of brandy rather than drinks made from local resources, as the Jesuits had been planning in the 1630s and 1640s.

To the north, by the 1730s and 1740s, the British had asserted their control over Hudson Bay. James Isham was a factor on the Arctic coast for the Hudson Bay Company. He later published his observations on life in the north and included a brief vocabulary of the language of the Cree nation, with whom the company traded furs and other goods. In that vocabulary, he noted that they had three words for forms of beer: small beer, strong beer

and spruce beer. They were being brewed at the fort and, Isham noted, were preserved by burying casks of beer below the frost line, digging cellars twelve feet deep.

Apart from the implication that the British were dealing in beer with their First Nation trading partners, it is also noteworthy that they were producing and consuming at least three types of beer. At this point in time, a cultural balance between Europeans and the First Nation seems to have been maintained, as Isham also reported that the Cree drank a fish broth as commonly as the British drank small beer. Beer remained functional, with each form of beer having its own purpose: Small beer would have been the daily drink for hydration. Strong beer would have been for cheer and intoxication. Spruce beer was brewed for its anti-scurvy properties.

The place of beer in the culture of New France in the mid-1700s was distinct, its production remaining more limited. Swedish-Finnish botanist Pehr Kalm, who travelled through New France in August 1749, mentioned beer as being a drink of the lower classes. One option was *bouillon*, a mildly alcoholic beverage made by the ancient technique of dropping raw, leavened dough into water. Another form was called *apinette blanche*, made from the white spruce.

Kalm also described how those in elite circles cooled their beer and wine in summer heat in addition to building ice cellars under their houses. He noted that it was "not yet customary here to brew beer of malt" and that the people of New France sowed "no more barley than is necessary for the cattle for they make no malt here." There were insufficient orchards for cider. Wine was shipped to New France at great expense.

As the Seven Years' War broke out, British forces operating against New France were familiar with the benefits of spruce beer, as well as the risks posed by its absence. In the 1750s, the borderland waterways travelled by both British forces and those of New France were the scenes of battle. Scurvy was a real problem for the British forces, with cases recorded at Fort Oswego and Fort Stanwix near Rome, New York. Spruce beer was the antidote, a fact known to Colonel John Bradstreet, who mustered the forces at Oswego and led the final raid on Fort Frontenac in 1758. Bradstreet acted as a quartermaster for the British and recorded in a letter from earlier in that decade his gift of a cask of spruce beer to his correspondent.

General Jeffery Amherst was commander of British forces assigned to the conquest of New France. He gave instructions to provide for spruce beer throughout his army. Following the fall of Ticonderoga in July 1759, Amherst noted in his diary that "our brewery things at last got up...[and]

will save several lives." He even set out the process for making spruce beer in his orderly book:

Spruce Beer will be Brewed for the Health and Conveniency of the Troops, which will be served at prime Cost; 5 Quarts of Mollasses will be put into every Barrel of Spruce Beer; each Gallon cost nearly 3 Coppers… Each Regiment to send a Man acquainted with Brewing, or that is best capable of assisting the Brewers, to the Brewery to-morrow Morning at 6 o'clock…One Serjt. of the Regulars and one of the Provencials to superintend the Brewery, who will be paid is 6d per Day. Spruce Beer will be deliverd to the Regiments on Thursday Evening or Friday Morning.

The defeat of France in eastern North America soon followed. With its fall, Fort Frontenac and Ontario's south were left unpopulated by the British and other Europeans. Other than the continuing population at Detroit, colonization of the Great Lakes was not in the plan, despite proposals suggested by Colonel Bradstreet years before. It was not until the events of 1775, as the shots fired at Lexington and Concord touched off the Revolutionary War, that the primary use of the St. Lawrence beyond Montreal was taken back again from the First Nations.

During the early decades of Ontario's history, there was a rich variety of strong drink identified in the records of both colonial powers. In addition to cider, wine and brandy, the French were familiar with barley beer, spruce beer and *bouillon*. The British drank no fewer than six types of beer prior to the arrival of the Loyalists: ale, strong beer, ship's beer, harbour beer, small beer and spruce beer. Examples of most of these brews would continue to be made in Ontario in the decades to come.

CHAPTER 2

BREWING AND THE
TWO LOYALIST WARS

1775–1815

The story of British Ontario as we know it today began in a tavern brawl in Albany, New York, in early June 1776 at the King's Arms Inn, where the town's Tory leadership had gathered with its supporters to celebrate the birthday of George III. Denounced by Revolutionaries as an indecent meeting and a daring insult, the event upset the tenuous balance in the community. The owner of the inn, Richard Cartwright, as well as his son, Richard Cartwright Jr., avoided the immediate fate of other Loyalists across the thirteen colonies who were jailed by Revolutionaries. Although they kept their liberty, the Cartwrights lost their tavern, their property and their livelihood before making their way north to Canada in exile.

They were joined by many others. To the west of Albany, one month before these celebrations, Second Baronet of New York Sir John Johnson fled north after becoming aware of a force being sent to arrest him and his supporters. He immediately set about raising the King's Royal Regiment of New York, recruited in large part from his farming neighbours and tenants. On both sides of the war, crops were destroyed, and any semblance of normal life was lost. The Loyalist force, during the course of the war, kept the breadbasket to the north and west of Albany from Revolutionary control. The Dutch breweries of Albany that had been active for a century and a half fell silent. The years of this war, like all wars, were bad for crops and brewing.

The British Loyalists faced the Revolutionaries from the string of French forts that they had themselves assaulted just decades earlier. The principal

strongholds on Lake Ontario were at Kingston and Niagara. Along with their Iroquois and Mississauga allies, these loyal former farmers raided south throughout the war, keeping much of upstate New York a deserted buffer zone. The British established their base of operations at Carleton Island, where the St. Lawrence meets Lake Ontario. As in the Seven Years' War, spruce beer was brewed for the Carleton Island garrison as part of daily life, with each soldier being given a ration.

During the war, the only beer being brewed from malted grain in Ontario was in the far north. The brewers of the Hudson Bay Company were producing casks that were still being buried deep in the ground to get them through the winter without freezing and bursting. In the south, evidence of the spruce beer brewing has been uncovered by recent archaeological studies in the Thousand Islands, according to Pippin's "For Want of Provisions":

> At the barrack excavation, a keg tap of the type used to distribute spruce beer was uncovered. A nearly identical tap was uncovered in the underwater excavations in North Bay, Carleton Island, and is on display at the Tibbetts Point Light House Museum in Cape Vincent, N.Y. Both Carleton Island examples had the distinctive keyhole spigot.

As the war continued, new mercantile interests developed along the trade routes protected by the British. In May 1780, Richard Cartwright Jr., who grew up in the King's Arms in Albany, left the British military to enter a partnership with Robert Hamilton. They became key suppliers to the Loyalist forces of many goods, including molasses, the key ingredient in spruce beer. The following year, Cartwright and Hamilton, with the help of their principal suppliers in Montreal, formed a partnership with John Askin of Detroit, expanding their trade. All of these merchants were eager to tap the lucrative fur trade and supply the British garrisons that ensured that trade remained constant. This was a common strategy and would continue into the early industrial period.

After the war ended in 1783, Cartwright, Hamilton and Johnson were among the core leadership of the Loyalist refugees that founded communities along the St. Lawrence Valley, as well as in the Bay of Quinte and Niagara regions. These settlers, as well as those who joined them from the evacuation of New York in 1783, were ale drinkers. Loyalists from Philadelphia—like the tailor James Pritchard, who took almost a decade to arrive in Kingston—would have brought their taste for porter. Those from the Albany region brought not only their farming skills but also

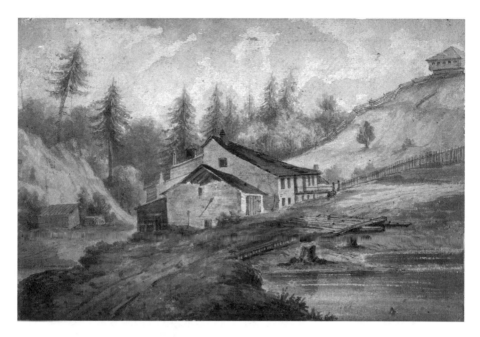

This sketch of the Bloor Brewery (which would have been situated on what is now the Rosedale Valley road) is fairly representative of the early industrial brewery in Ontario. Note the flammable wooden construction. *Courtesy of Toronto Public Library.*

knowledge of the strong wheat ales of Central New York. The beers of New York brewers like Anthony Lispenard, as well as the Taunton ales imported from England, had been popular before the conflict and were not forgotten. One of the prized possessions of Reverend John Stuart, the first Anglican priest in Ontario, was his silver ale tankard, which now sits in the collection of Canada's Museum of Civilization.

Among the waves of Loyalists in the 1780s came brewers seeking to supply the market in accordance with those cultural expectations. As regional beer historian Steve Gates has shown, however, many Loyalists were quite capable of both supplying their needs and commercializing their activities. Samuel Sherwood of Fredericksburg and Paul Trumpour on the Bay of Quinte appear to have been brewing as soon as they settled. Henry Finkle in Bath is often referenced as the first commercial brewer in Ontario. He opened a tavern dating at the latest from 1786 at a site just west of the village of Bath.

Joel Stone, the founder of Gananoque, traveled from Connecticut to England in October 1783 to train as a brewer. Writing to his father early in 1788, he explained why he was not returning to New England but

rather staying near Cornwall: "I have begun making malt, brewing beer, and distilling spirituous liquors from wheat, barley, rye etc." Whomever is identified as the first Loyalist brewer is mostly a matter of the current state of the records of these early loyal American refugees. In any event, if the Hudson Bay Company was selling or trading beer, the first commercial brewing operation may have been far to the north and an entire century before the Loyalists arrived.

There were factors other than the cultural will to brew that affected the early Loyalist era. Settlement was both sparse and controlled. In 1787, the population was described in official communications as "mostly farmers from the back parts of New York Province." Ontario, the western township of the Province of Quebec, was under a form of martial law until 1788, when the Court of Common Plea was established. Perhaps only ten thousand settlers had arrived by the date of the division of Upper Canada from the Province of Quebec in 1791. Even with the provisions and protection supplied by Britain to those identified as loyal and allowed to enter, the Loyalists' main plan in the mid-1780s was simple survival, even if members of the elite such as Cartwright, Hamilton and Johnson consolidated their estates and mercantile positions.

The struggle for survival would quickly become work toward prosperity. In 1789, Reverend John Stuart reported that grain was scarce. Over the next two years, there were records of grain exports. In 1792, Niagara, at the west end of the territory, was reported as being self-sufficient in grain. Loyalists were transitioning from reliance on stores of goods supplied by government to supplying themselves from their own farms. They were moving from living in and around garrisons and encampments to building self-sustaining communities. Instead of the spruce beer that they had grown used to, small-scale brewing provided the styles that the soldiers and refugees had known before the war.

The economy of the Loyalist community stabilized and grew as it entered the 1790s. There were three distinct forms of drinking during this period. Small-scale commercial or domestic brewing continued but was based increasingly on local resources. Spruce and malt beer continued to be brewed in the garrisons under the British military's obligation to provide for the troops. Elite social drinking of a range of imported beverages also existed at levels not seen since the taverns of Albany or Philadelphia. The newly separate colony of Upper Canada came into being in 1791, with its first capital established at Niagara-on-the-Lake in 1792. The creation of Upper Canada came about in response to its Anglo-American leadership's

wish to live under the British common law that they were used to from before the war. The change would weaken the political and commercial control from interests established at Montreal and Quebec City. Along with separate colonial status came the imposition of new forms of regulation and opportunities for commercial investment in brewing.

Some brewers, like Finkle in Bath, continued to brew in small-scale operations, supplying the local community and the travelling public, while others extended their business interests as new opportunities arose. As the settlements matured, greater opportunities for people of ambition lay in producing flour and potash for the Montreal markets. The British military still provided soldiers with daily rations of beer. Where previously military units supplied their own beer, as it had been in the 1750s under General Amherst, it was now being purchased wholesale as brewers worked increasingly with malted barley.

In the garrison communities of Kingston and Niagara-on-the-Lake, larger and more formal breweries were founded to supply the colony generally and the troops in particular. They were built with government approval to provide beer to the colony and its protectors. In 1793, at Niagara-on-the-Lake, John Hewitt placed a notice announcing both establishment and official approval of his brewery. It was set to open in time for that year's grain harvest. In that same year, John Forsythe built his brewery in Kingston at the end of the aptly named Brewery Street. Forsythe appears to have been an investing capitalist, apparently without the skill or inclination to brew the beer himself. He moved through a number of partners and tenants before John Darnley took over operations in 1797. Darnley managed the brewery until 1810.

After the colonial capital moved from Niagara-on-the-Lake to York, the future Toronto, brewers sought to locate themselves nearer the administrative elite there. As with the more formal licensing of breweries, relocating to York also required official permission. In 1796, the same John Hewitt petitioned the Executive Council for a half acre of land on the shore at York for the express purpose of founding a brewery. His request was refused. Hewitt received two hundred acres to farm in Scarborough in 1797 on the strength of his wife's petition and superior Loyalist credentials. Another Niagara-on-the-Lake brewer, Thomas Otway Page, petitioned to move to York but was also denied permission to relocate by the Executive Council in 1796. Surviving a few years of the departure of the colonial elite, the brewery in Niagara was put up for sale in 1799.

Two issues appear to arise in these petitions by brewers to move to York. There might have been some concern about the proof of Hewitt's loyalty,

This detail from an urban planning request in 1802 displays the first known brewery site in Toronto. The importance of water as a source of power to the brewery is clearly displayed by the necessity for an oddly sized lot. *Courtesy of Toronto Public Library.*

This photo displays Henderson's brewery, which was built on the site asked for in the planning request. Although it was a blacksmith's shop by the time the photograph was taken, the building is original. *Courtesy of Toronto Public Library.*

as well as concerns related to having beer brewed locally instead of being brought in from Kingston and Niagara. Social control and security were important matters in the first years of Upper Canada. The prospect of another war with the United States was also a serious fear. There was no rush to expand the towns or open the land to unfettered settlement by those whose allegiances could not be trusted.

There were fewer than twenty houses in York in 1795. Abner Miles had established and expanded his tavern at King and Caroline Streets to include a public house, providing room and board for travellers. In the rugged conditions of the new settlement, his tavern, like that of Finkle's in Bath, was one of the few centres where farmers and townsfolk could gather for recreation and discussion. Since York lacked public buildings of any size, Miles's tavern became a focal point for such social activities as auctions, dances and special celebrations, including Masonic dinners. All the annual town meetings between 1798 and 1803 were held under the roof of this tavern.

The tavern's daybook illustrates drinking preferences of the governing elite who gathered there in 1798. Merchants Hamilton and Cartwright, along with Commodore Grant and Chief Justice Elmsley, enjoyed a wide range of strong drinks with their meals and afterward. They drank an impressive number of bottles and bowls of white wine, syrup-punch, brandy, rum, port, Madeira, gin sling and sour punch, along with mugs of beer and bottles of porter. The variety of drink indicates that, at least for the elite, tastes were as varied as the range of imports from across the empire would allow. The imported porter also illustrates a commercial connection to imperial and global brewing that continues to the present.

Other significant changes to drinking patterns appeared at the beginning of the nineteenth century. Garrison drinking changed fundamentally with the replacement of the supply of small beer to troops of the British military with an allowance of one penny a day in lieu of the ration. The official order of March 17, 1800, ending rations begins, "Whereas it hath been expedient for our service to discontinue the supply of small beer to our troops when stationed in barracks and when billeted in settled."

The implication of the order is that many British troops are being located in stable settled locations throughout the empire—places where brewing was possible. Beer was often sold directly to soldiers from small, crude, tented structures by sutlers. The order replaced the monopoly of supply to the military from single brewers with a more competitive system in which smaller breweries were more able to flourish.

An example of this new opportunity was found in Upper Canada's new capital of York. Despite requests from brewers to relocate, York remained without a brewer from 1792 to 1801. Preparations began in 1800 for a brewer, Richard Henderson, to move from Kingston to York. A survey of the brewery property at the northern edge of the small community dated October 14, 1800, was approved by the chief justice himself. The survey shows that a road needed to be rerouted to accommodate the site of the brewery. The brewery was located at the corner of Duchess and Caroline, two blocks north of Abner Miles's tavern. The irregular angle now at the corner of Sherbourne and Richmond Streets in Toronto still reflects this change to the layout of the town.

As the colony's administrative centre, York was unlike older Upper Canadian communities. Reporting the move to the bishop in 1801, Kingston's Reverend John Stuart wrote, "The Town is a Hot Bed, where every Thing is forced, unnaturally, by English money. I know of no Trade now existing, or to be expected at any future Period, to support or enrich it."

Local resources were not sufficient to support the brewing of beer. The brewery required the governor's permission for a ship to carry "wheat and other grain from Kingston…before Beer could be made." It is also important to note that the brewery was supplied with "wheat and other grain." Brewers would not have had access to pure malt barley supplies. While passing through on the way to establishing his settlement near Windsor in 1803, Lord Selkirk recorded the use of malted wheat in brewing strong ale when visiting a brewer and distiller at Geneva in Western New York.

Beer brewed at York was not solely for garrison use. Abner Miles hired Ely Playter to manage his tavern, and from February to September 1802, Playter kept a diary of events at the tavern and in his life. The tavern continued to serve a variety of imported drinks and domestic beers. By 1802, there were between seventy-five and one hundred houses in York, and Playter's Inn had fallen in importance while aspiring to maintain the exclusive clientele that Miles had earlier been able to attract. Rougher grogshops set up to the north edge of the town near Henderson's brewery.

"Rough" was often the word. One early brewer in Upper Canada was Margaret Simpson of Belleville. Having settled in Belleville in 1797, she became sole proprietor upon the untimely passing of her second husband in 1802. With the help of her two small children, she carried on the daily running of a frontier tavern and brewery, in in addition to other businesses, for the next twenty years. The reviews of the product were middling at best. As one traveller noted, "There being but two or three shanties, among

them Simpson's Tavern, at the rude bar of which the sole drink was a home brewed beer, which, however, possessed intoxicating qualities."

As the decade progressed, the settlement of Upper Canada and resulting opportunities for settlers continued to expand. Henderson placed an ad for the sale of his malt house, brewery and other properties in the June 24, 1809 edition of the *York Gazette*. It was purchased by Shaw, who continued operations. Abner Miles relocated north and opened another tavern in Richmond Hill. According to an 1808 notice in the *Gazette*, Upper Canadians learned of the opening of the Red Lion tavern on Yonge Street, described as a "beefsteak and beer house" where the owner, Daniel Tiers, promised to "furnish the best strong beer at 8d. New York currency per gallon if drank in his house, and 2s. 6d. New York currency taken out as he intends to keep a constant supply of racked beer."

This strong beer may have been from Henderson's brewery or may have been brought in from Kingston. Even in 1815—after years of established brewing at York—8,347 gallons of beer and liquors were still being brought into the capital from Kingston. The beer served at the Red Lion may even have been from New York State, as a trading ship from Oswego to Kingston and York was established in May 1797. Prior to the War of 1812, Upper Canadian leaders with their upstate New York connections welcomed trade with their Federalist cousins and encouraged their immigration as long as they fit with the conservative vision.

Those relationships were crushed by the War of 1812, as was much of the agricultural and brewing economy in the western end of Upper Canada. The St. Lawrence Valley remained largely peaceful, with dinner parties being occasionally exchanged across the border dividing Ogdensburg from the fort town of Prescott. By contrast, the Niagara border was the scene of prolonged and vicious warfare. Control of much of the colony to the north of Lake Erie was lost to the British after the Battle of the Thames in October 1813. As we shall see, the postwar years were marked by a much stricter political divide with America, which would change the direction of Ontario's brewing and beer.

CHAPTER 3
UPPER CANADA BECOMES CANADA WEST AND EXPANDS

1815–1860

BEER IS HEAVY AND THE ROADS ARE POOR

The civilian settlement of Upper Canada by the British began in earnest after the War of 1812 and was dictated by the location of military defenses, which had been structured in response to the threat posed by the United States. The main strength of the economy of Upper Canada in its early days was as an exporter of natural resources like potash and wheat, as well as timber and furs. It was for this reason that the vast majority of early settlements found themselves situated on the shores of the Great Lakes or on rivers that provided a passage to the interior with minimal effort. This allowed a connection to the forwarding trade already established along the St. Lawrence.

Away from the waterways, roads reaching into the forest were basic. While passable in the winter, they would become muddy quagmires during the spring and autumn. The Governor's Road between Hamilton and London was cleared for military use between the fall of 1793 and the spring of 1794. The members of the Queen's Rangers tasked with the land clearance faced rattlesnakes, wolves and the Canadian winter. The best you could say of the result was that it amounted to an improvement over pathfinding.

The problem was not limited to the western frontier. In more established areas of Upper Canada, the transit by land was similarly underdeveloped.

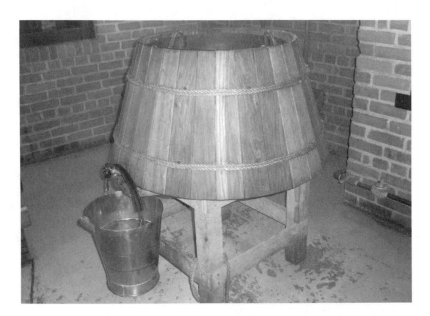

In an early tavern-sized brewery, the mash tun was constructed in much the same way as a barrel, but with a copper interior. *Courtesy of Black Creek Pioneer Village.*

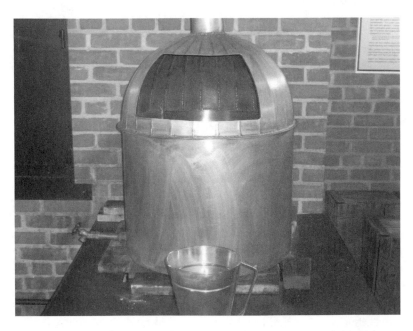

The brew kettle in a tavern or farmstead brew setting would usually be a large pot, but this hooded example would have provided a better result. *Courtesy of Black Creek Pioneer Village.*

While it was possible by 1817 to receive mail by stage in Toronto from Montreal in a week, the vast majority of that time was spent on roads between Kingston and York. The steamboat *Frontenac*, launched in 1816, would have accomplished the Kingston–York leg in less than half the time.

Given the limits of inland transportation, it is easy to see why practically all of these settlements were strategically located next to water. In many cases, the lesser geographical boundaries in Upper Canada were laid out by the surveyor decades before anything amounting to a village existed in the region. John Graves Simcoe had high hopes when he determined in 1793 that London should be the site of his capital. It did not possess the population necessary to be considered much more than a village. The great migration of settlers was due in part to the loss of employment that occurred in Britain due both to the industrial revolution, as well as to the suddenly unemployed population at the end of the Napoleonic Wars.

Britons who left for Canada West were choosing the unknown in hopes of a freer life. What they found in the early years in the new land was unlike anything they had seen before. The frontier life was hardy and given to what today might appear as excess. At a celebration of the birthday of King George IV, hosted by the Canada Company on August 12, 1828, two hundred settlers gathered. A whole ox was roasted, held over the fire with logging chains. As there were few utensils, most of it was eaten off wooden shingles with minimal cutlery. After the feasting, "Toasts were drunk to everybody and every conceivable thing, the liquors of all imaginable descriptions being passed round in buckets from which each man helped himself by means of tin cups." It is recorded that many attendees were found the next morning reposing on the ground in the marketplace "in loving proximity to the liquor pails."

Upper Canada was so popular a destination for emigrants that by 1860 Catherine Parr Traill's work, *The Canadian Settler's Guide*, was in its tenth edition. Farmland was sold for token amounts or given away if suitable tenants could be found for the property. While the land may have been inexpensive, the realization of its potential would require a lifetime's commitment in homesteading. Settlers also chose Upper Canada based on the promise that infrastructure would be built around their efforts. Emigration was a calculated risk: substantial wealth could be gained in the long term by claiming and clearing vast tracts of land.

These immigrants were familiar with the habits and tastes of late Georgian British society. This led to clinging on to familiar habits—eccentric behaviours like drinking punch in frontier cabins and pining for the "sweet

31

The barred cool ship would be lined with hay to catch hops or grain residue as a form of filtration during the cooling process. *Courtesy of Black Creek Pioneer Village.*

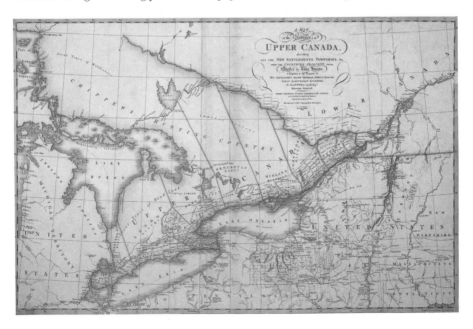

In 1818, the majority of the population was settled within a very short distance of the lakes and waterways of Ontario. *Courtesy Wikimedia Commons.*

well-flavoured home-brewed beer of the English farmhouses." It was part of the societal identity they brought with them. They were seeking a better life, not a different culture. They carried with them all the knowledge required to brew beer.

The difficulty is that the perfect replication of British farming society on the frontier took years, and barley for brewing was simply not a priority to the homesteader. Studying gazetteers and surveys from the period, it becomes clear that regardless of the specific ethnicity of the settling population, nearly the same progression was to be had on every settling site. After the initial land clearance, the dominant crop was wheat, with corn, oats and potatoes being relatively common as well. Barley's primary use to a farmer was as fodder for livestock. Although ninety-three years old at the recounting of his life's story in 1913, Peter Bristol of Napanee recalled that he was "twenty years old before I saw any barley or knew what it was."

In the newly settled towns, the infrastructure of brewing arose near flowing sources of water. The strategic placement on a river allowed for both a source of power for a mill and transport for grain and flour. Not infrequently, the more enterprising among the settlers would take the opportunity of setting up complementary businesses next to the local mill. Absalom Shade, for example, claimed and repaired an abandoned sawmill and gristmill on the Grand River in 1818. He was able to parlay that success into a store that would provide goods for settlers on credit and, two years later, a very successful distillery. It is not for nothing that Galt, Ontario, was once known as Shade's Mills.

At the point in development when these basic needs were fulfilled, you might also get a frontier tavern. Frequently this would be built before the church, sometimes serving as one in the interim. In smaller settlements, a tavern might function informally as a hostelry, a post office and a general store in addition to serving food and beverages. Taverns would frequently produce their own beer, which would have been of higher quality than the meager farmhouse fare that Upper Canada could support, if only because of the faster turnover rate that a larger population could ensure. It would certainly have been flavourful, but that might not have been a positive quality.

The beverage of choice in Upper Canada during the frontier population boom of the second quarter of the 1800s was whisky. It had many advantages over beer in a frontier environment and would have been just as welcome to the Scotch-Irish immigrants as beer would have been to the English and American Loyalists in the older towns. Whisky could be made with the wheat and corn that constituted the vast majority of agricultural yield. It packed a

Beer was largely fermented in individual barrels in early tavern breweries in Ontario. As you can see, portability was wanting. *Courtesy of Black Creek Pioneer Village.*

great deal more alcohol in the same liquid weight and volume. It would not spoil during transit. It would not spoil once opened. It was affordable. A gallon of whisky in York was one shilling sixpence from the distiller. A barrel of ale might have been proportionally cheaper, but just try carrying a few months' supply back home from town. Beer was heavy, and the roads were poor.

It is easy from a modern point of view to look back dismissively on the efforts of these pioneer brewers of Upper Canada. For a modern brewer, there are many dozens of varieties of malted barley to choose from, including subtle and minute gradations in level of roast. The frontier home-brewer would have had to become familiar with molasses, beets or maple sap for the most part. Getting barley at all would have been a challenge. Malting in sufficient quantity for use at home would have required expertise and time that simply would not have been available to the majority of settlers. The first requirement of a professional brewer upon choosing a site and erecting a brewery would have been acquiring barley and other grains sufficient to the task of brewing. We know that there was relatively little barley in Upper Canada, but it would certainly have been possible to obtain enough to begin creating a steady supply.

A common tactic to encourage barley crops was advertising in whatever periodicals were available to let farmers know that barley would be a cash crop in future. If further encouragement was required, a brewer might even give away seed for a crop of barley and offer to pay for the quantity harvested. In many ways, it was an unbeatable arrangement for farmers. Such messages were laced with local and imperial pride and were justified by the ads for New York's Albany Ale appearing within a year of the end of the War of 1812. Calls to protect the brewing industry in Upper Canada emerge as early as 1820 in the *Kingston Chronicle*:

> *Your petitioners have witnessed the beneficial effects resulting from the establishment of the aforesaid Breweries, the liberality of their proprietors, having held out a degree of encouragement to the Farmers of the Midland District, for the growth of Barley, far superior to any that could have been offered by those noble institutions the Agricultural Societies… Your petitioners enter deeply into the feelings of our disappointed and neglected Brewers, and your petitioners will doubtless soon have to commiserate the misfortunes of the general mass of farmers, unless your Honourable House immediately condescend to pass an act imposing such duties on the Beer, Cider and Barley of the United States as shall effectually prevent their open admission into this Province.*

Cries for economic nationalism did not come only from brewers' concerns with the industrious Americans to the south. Slightly later that year in the same paper, an advertisement appeared from a brewer newly settled in Kingston: the Birmingham-born Thomas Dalton. He was pleased to announce the sales of "Rich Flavoured Ale" at his brewery, the largest concern in the province at the time despite its relative youth. He further cautioned local farmers against exporting cash from Upper Canada to pay for tropical rum from another corner of the empire:

> *He thinks it will not be amiss to remind farmers (who are the mass of the people) that if they wish their grain to command cash, they must absolutely make Malt Liquor their common beverage, and thus support the Canadian Brewers instead of the West Indian Distillers. It is of serious consequence, both to themselves and to the whole country, that they should immediately adopt so praiseworthy a resolution.*

Concerns with foreign competition were keenly felt. The initial investment in a brewery would prove costly not only as a result of the capital required to

purchase the brewing equipment and create a workable setup but also for the purchase of a first year's crop of barley. We tend to think of the process of brewing ale taking about three weeks from mash tun to foaming mug. Malting would easily add an additional three weeks to the process. And in order to guarantee their investment, someone would need to check on and turn the malt on a regular basis throughout the day and night. For this reason, even a relatively small production brewery would require several employees. No wonder brewers sought to protect their market.

In addition to competition in the marketplace, brewers were fighting the seasons. Malting and brewing generally took place in the autumn, winter and spring due to the fermentation-ruining temperatures of the summer months. In some ways, winter was a godsend. With the ground frozen solid, the transport of goods would become a deal easier. The Helliwell brewery, started in 1820 at Todmorden Mills on the Don River northeast of York, gives us two historical sketches of a brewer's winter. The Helliwells had previously been living at Lundy's Lane near Niagara Falls. When they moved to the settlement at York, they brought their brewing copper with them. Mrs. Helliwell travelled in the copper with her youngest son on her knee. It was situated on a flat sleigh, drawn by a team of four oxen around the headland of Lake Ontario. Such a journey would have been a great deal more treacherous in the soggy spring or autumn, when the roads might be only slightly better than impassable for such heavy freight.

The cold was not always beneficial to an early industrial brewery. During Thomas Helliwell's 1833 production season, attempts to malt at his Todmorden Brewery were shut down for the first week of March because it was simply too cold for the barley to chit prior to kilning. Within mere decades, technological developments and improved brewery infrastructure would render such problems a memory. Staring down the loss of profits due to a delay in the production cycle, one assumes that this news would have been of little consolation.

Malting was time-consuming and exacting but not particularly difficult to teach. It requires a knack that a layman might be able to pick up under supervision. Simply by changing the duration a batch of malt spent in the kiln, or by changing the temperature inside the kiln, one could produce several different varieties of malted barley. Transplanted British brewers would have brought this technique with them from the old country, resulting in the ability to brew several different styles of beer. The technology would have spread rapidly as former employees moved from brewery to brewery disseminating the techniques.

Skilled malting was needed to succeed in popularizing a product among the educated, ale-drinking palates of Upper Canadians. The wave of British settlers after the War of 1812 would have known a number of different sorts of beer while living in the mother country. Further, at least in Kingston, York and Hamilton, imported beer of high quality would have been available. Bass Pale Ale had been brewed in Burton on Trent since 1777 and would probably have been experienced by two generations before the period of immigration. The English had no more forgotten their preferences than had the New York Loyalists before them.

An advertisement placed by Thomas Molson's brewery in Kingston, founded in 1824, makes it clear that the consumer expected a wide variety of products. At the top of the range were brown stout and strong beer at seventy shillings a hogshead. Porter followed at fifty-five shillings. Brown, pale and amber mild ales sold at fifty shillings. Finally, you had table beer or ship beer at twenty shillings. Packages of twelve bottles were correspondingly priced, and it is worth noting that even in 1825, there was a bottle and cask deposit. This wide variety would not have existed had not Upper Canadian beer drinkers been raised as a discriminating bunch in a beer-drinking culture.

Many of these new entrepreneurial British brewers were from a relatively compact portion of industrialized England. It should not be entirely surprising that many of the new brewers came from communities relatively close to Burton on Trent—one of the largest brewing centres in the world at the time. Many of the English immigrants to Upper Canada came in the wake of mass unemployment due to technological improvements in farming, not to mention unlivable wages and conditions. In England, this situation led to the Swing Riots of 1830, a sort of neo-Luddite movement during which threshers were destroyed and Wellington's government defeated.

After the fall of Napoleon, Britain became deeply conservative. That the Duke of Wellington should have become prime minister speaks to the military authoritarianism of the period. After the War of 1812, the government of Upper Canada mirrored this attitude. By 1816, Richard Cartwright was in the grave, and power was shifting from the Kingston Anglo-Loyalists to the British officials at York known as the Family Compact. Upper Canada's two lieutenant-governors from 1818 to 1837, Sir Peregrine Maitland and John Colborne, First Baron Seaton, both fought at Waterloo as part of Wellington's senior command.

Life during the period of Family Compact dominance was not yet affected by temperance in any organized sense. Drinking was pervasive, especially in garrison towns. At the end of the era in 1842, Kingston had 136 licensed

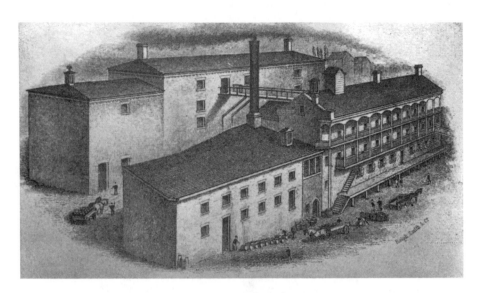

This lithograph represents the Severn Brewery, located in the Rosedale Valley in Toronto. The brewing process in the second generation of breweries is compartmentalized. Note the packaging building in the foreground. *Courtesy of Toronto Public Library.*

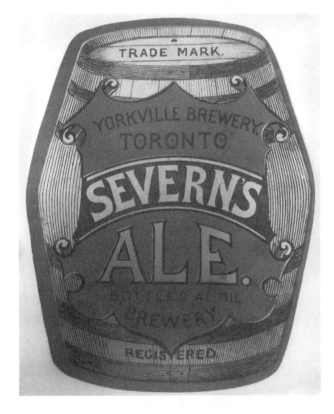

The Severn Brewery was among the early adopters of labels with custom designs. *Courtesy of Molson Archives.*

establishments for a population of no more than nine thousand. It was a "town over-run with drunkards." The question to Georgians was solely one of personal fitness for public office. The governor of the new United Canada in 1841, Lord Sydenham, was positively scandalous. His "sacrifices to Venus were scarcely less copious [than] those rendered to Bacchus," with culinary tastes running from turtle soup to porter and champagne. Temperance, as a movement, was still some years from its advent.

York's first new brewery in this era was built on land owned by the army. In October 1820, John Farr petitioned for the license to open a brewery on the garrison's lands west of the city, across from what is now Trinity-Bellwoods Park. Farr's petition allowed him to establish his brewery, but perhaps the most important information that it conveys is the tone Farr used in addressing the government. It is not merely deferential or respectful but actively obsequious, as one might use addressing one's better: "Your Petitioner therefore prays that Your Excellency may be pleased to obtain for him a Licence of Occupation during pleasure of the said piece of Land, subject to any conditions Your Excellency may be pleased to direct; or any other title which may be more approved of."

The imperial allegiance and grip of the Family Compact was such that, by the 1820s, Upper Canada was actually more conservative than England in certain ways. There was the imposition of severe tariffs on goods being imported from the United States. Upper Canadian businesses willingly paid nearly double for local hops and barley that might be gotten from the United States for less money. In 1820, it became clear that "a moderate duty on imported Beer will have little or no effect in raising the price of our own, is shown by the fact the price of beer was the same in 1818 (when there was a duty of sixpence per Gallon on imported beer) as it is now."

Unlike the Methodism or Presbyterianism of many of the earlier American Loyalists, the Family Compact were devoutly dedicated to the Anglican Church and to the hierarchical class structure that was beginning to come unravelled in England itself. Political power was concentrated and access to it barred by tight-knit societies. Their belief was that Upper Canada was not ready for responsible government by the democratic rabble. In practice, this resulted in a thoroughly corrupt and nepotistic system that remained in place until it was removed by a series of political reforms.

If you can imagine being a moderately well-to-do immigrant to Upper Canada from the English Midlands in the 1820s and 1830s, you can understand why they might take umbrage at exposure to this situation. It was exactly the kind of abuse of power that had been causing trouble at

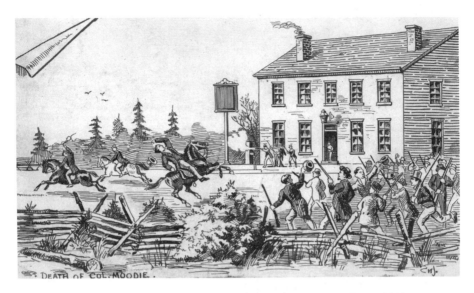

This imagining of the shooting of Colonel Robert Moodie on December 5, 1837, prominently features Montgomery's Tavern. The rebels chose to position their roadblock close to the taproom, where there was warmth and ale. *Courtesy of Toronto Public Library.*

In an urban setting, the early industrial brewery was less of a ramshackle affair due to the constraints imposed by nearby properties. This is a sketch of John Doel's brewery at the northwest corner of Bay and Adelaide in Toronto. *Courtesy of Toronto Public Library.*

home. While England instituted some reform in 1832, Upper Canada was massively reticent to do so. In the long term, reform was likely inevitable due to the migration of peoples from Europe, which the Family Compact had actually brought on itself. In a sense, the entire Upper Canadian conflict of 1837 was a late echo of the English political realities of 1830.

Given the experience of the parties involved, it's not surprising that the brewers from the English Midlands came down on the side of their customers in the fight for reforms leading to the rebellion of 1837. Despite the tone of Farr's petition to be allowed to open a brewery, that same property was used as a meeting site for the rebels in 1837, and it is not as though his was the only one.

John Doel's brewery stood on the northwest corner of Bay and Adelaide in Toronto between 1827 and 1848. In addition to brewing, Doel, born in Wiltshire, was also a radical reformer who served on the Toronto City Council and supported Mackenzie. His support for reform was such that the Declaration of the Reformers of the City of Toronto was signed at a meeting held in his brewery in the summer of 1837. Doel was not in favour of armed rebellion himself, being a brewer and not a fighter. There is evidence that meetings of the rebels continued to be held at the brewery until two days before the insurrection on December 7.

This highlights the important role of the brewer in the communities of early Ontario. While taverns would certainly act as meeting places, one needed a reason to go there, and the brewer provided it. Besides which, the brewer was, by the nature of his work, in contact with a vast cross-section of the population in a period when beer was safer to drink than water. His finger was on the pulse of the community. Communities could be vastly different despite their proximity. While the first great emigration after 1815 had been from England, settlers would continue to arrive from Scotland, Ireland and Germany. The frontier, divided into neatly geometric surveyed townships, began to fill up in short order after 1820, with large groups being located together all at once based on their identities. The beverage of each newly settled community would be defined by the brewing traditions they had experienced.

One cannot understate the influence of Irish immigration on the history of brewing in Upper Canada at this point. As early as 1822, there were schemes in place to deliver impoverished Irish citizens to Upper Canada. Primarily from Munster, the Irish were not immediately invested in such programs, equating them largely with transportation. Transportation typically carried a punitive component of seven years of indentured servitude and a journey that might end in Van Diemen's Land. However,

given the widespread poverty and concurrent inflation, typhus epidemics and the unrealistic demands of the newly instituted Insurrection Act, Upper Canada began to look like a fine option.

There are two facts that characterize Munster in terms of the history of drinking in Ontario. The first is that a religious distinction existed that rendered integration into the urban communities difficult. The majority of Irish settlers in Upper Canada were Roman Catholic, and this put them immediately at odds with the Anglican power structure of the province. For that reason, at least initially, the Roman Catholic Irish were given land at some distance from the capital. Nearly two thousand Irish settlers made their home in Peterborough, named for Peter Robinson, who arranged their immigration in 1825.

The second important consideration is that their tastes were set long before arrival. The main port through which they would travel, Cork, housed one of the largest breweries in the world in the form of Beamish and Crawford. Founded in 1792, its output in 1805 would have been just over 100,000 barrels of beer annually. While there were certainly exports to England, the majority of that beer would have been consumed locally. Beamish had been making porter at an astonishing rate for two generations prior to the majority of immigration to Upper Canada, and it is reasonable to assume that it was the standard for the newly arrived Irish settlers.

The religious conflict that was present in Ireland didn't always stay there, even for emigrants. Take, for instance, James Calcutt. Calcutt had started his own brewery as a teenager. He was forced to immigrate to Cobourg after being denounced from the altar during a Roman Catholic service. A local by the name of James Demsey took it on himself to drive Calcutt out of his home and business in Mountmellick (also the birthplace of John Kinder Labatt). Calcutt was surprisingly resilient and might be on record as having the shortest amount of time elapse between his arrival in Upper Canada and the founding of his brewery. Arriving in 1832, he was up and running by that winter's brewing season, according to advertisements in the *Cobourg Star*.

In the interim, Demsey had decided to voyage to Cobourg, possibly with the intention of finishing Calcutt once and for all. On November 14, 1832, Demsey's corpse washed up on the shoreline of Calcutt's property in Cobourg, discovered by Mrs. Calcutt. Reportedly, the steamboat on which Demsey had made his journey jostled the pier while docking. Demsey was knocked overboard and had the great misfortune to drown in Cobourg Harbour. That version of the story might seem improbably convenient, especially since many of the properties Calcutt built were equipped with

security features like bolt holes and secret tunnels. Those seem the actions of a man preparing for the worst.

Irish immigration began in earnest in the early 1830s, with more than half a million transplants to Canada before mid-century. Removed from the urban lakeshores of Upper Canada, the Irish settlers in Peterborough did not have any kind of durable industrial brewing projects until the 1850s. Seemingly, the preference in the area was for distilled spirits, as the sheer number of distilleries listed in the area in *Smith's Gazetteer of Canada West*, specifically those in Cavan, Keene and Lindsay, would have provided Peterborough with enough alcohol to be going on with. Unfortunately for Calcutt, shipping beer in any kind of quantity from Cobourg was untenable over uncertain roads.

Where there had been mass unemployment in the old country, Canada West had no shortage of opportunity for an enterprising man. Where there had been famine and starvation, there was plenty. In order to best utilize their gifts, the brewers from Ireland would be forced to settle in cities near their countrymen. The best example of an initial foot put wrong came courtesy of Patrick Cosgrave. While he had all of the requisite training to make his transition to life in Ontario as a brewer, his choice of initial location proved less than ideal. Located on the Credit River in Etobicoke—then known as Pucky Huddle—Cosgrave had access to both water from the river and barley from the local farms. What he lacked were customers.

Such was the size of Toronto in 1852 that its streets had not expanded far enough west yet to support a brewery in that location. The majority of the porter-drinking Irish immigrants were located within the city, and by 1862, it had proved more effective for Cosgrave to align himself with Eugene O'Keefe. He would subsequently find himself proprietor of the West Toronto Brewery, which he would hand over to his sons. The influence that porter had on the market in Ontario meant that brewers would go out of their way to infringe on the trademark that Beamish employed in Ireland.

The Copland Brewery in Toronto, located very near modern-day Corktown (named either for the concentration of Irish from Cork or for the distilleries nearby), would use the shamrock as its trademark. Not only did it lend a sense of belonging to the nearby consumers, but it also suggests that the symbol might have served as an identifier to a population that would not have been entirely literate. Fellow brewer and philanthropist Enoch Turner's schoolhouse, located just over the road, would eventually help to improve literacy. In the meantime, Copland would quench your thirst.

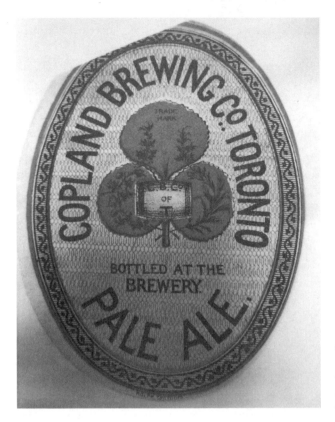

The Copland Brewery could use the shamrock with some subtlety, as seen here. *Courtesy of Molson Archives.*

The western section of Upper Canada found itself home to emigrants from the United States in the earliest days of the nineteenth century. Often thought of as the Pennsylvania Dutch, that is something of a misnomer. The wave of settlers who went to Pennsylvania was from regions in southwestern Germany like Baden-Wurttemberg, Alsace and the Rhineland Palatinate. This was a region that spoke a High German dialect, a factor that contributes to the misidentification, pronouncing "Deutsch" as "Dutch."

During the first decade of the nineteenth century, the majority of the settlers in Waterloo Township were Mennonites. Waterloo has a distinction among places in Ontario in that its heritage is visible from above. The geographic layout of the town is based on a European town layout that features a pattern radiating from the center of the town century, the majority of the settlers in Waterloo, rather than the more harshly regimented square grid system that is symptomatic of Upper Canada's surveyors having paid a visit. This gives you some idea of how early in the development of the province there was a German influence.

By 1819, German settlers were arriving in western Upper Canada from Europe. They were given a site to settle to the southeast of Waterloo that was named Berlin in honour of their heritage. As luck would have it, the new settlers came from nearly the same part of Germany. To understand why the German settlers came from Baden-Wurttemberg and the Palatinate is comparatively simple. The regions had been subject to some significant privation during the years following the Napoleonic Wars. In 1816, the Palatinate was subsumed by the kingdom of Bavaria despite the fact that it was more politically progressive—a fact that would lead to substantial bloodshed in 1848 in the revolution; Baden-Wurttemberg also went through one of the worst harvests in its history that same year.

It is from this poor harvest that we're able to learn something of the beer culture that existed in the region at the time. The next year, in 1817, King Wilhelm of Wurttemberg introduced the Cannstatter Volksfest in Stuttgart to celebrate the improved bounty. Behind Munich's Oktoberfest, it was the second-largest agricultural celebration in Germany, and local breweries were, in no small part, responsible for the merriment.

The first brewer on record in Waterloo Township was George Rebscher, who opened his establishment in 1837. It should come as no surprise that Rebscher, as a German brewer from Hesse in Franconia, brought with him the brewing techniques that were used in his homeland. Rebscher was the first brewer of lager beer in Canada, if not North America. What we cannot know is exactly what the lager might have been like. It seems likely that the unfiltered styles that were popular in Franconia might have represented some of the early output.

Given what we know of brewing in the early stages of a settlement in Upper Canada, it is relatively unlikely that George Rebscher's lager would have been made entirely of barley for the first year or two of production. It is unlikely that *kellerbier* would have made an appearance in the first year of brewing in the settlement of Berlin. To keep it through the summer would have required a cellar of some depth and a substantial amount of ice. While possible, this was not necessarily practical. In addition, *kellerbier* is typically reasonably heavily hopped. We may assume that hops would have been scarce in any early settlement.

Zwickelbier seems a far more likely candidate for the first lager brewed in Canada. For one thing, recipes traditionally called for very little in the way of hopping. For another, the beer is usually carbonated by stopping the barrel toward the end of fermentation. A *zwickel* is a sampling valve or spigot attached to the fermenting vessel, and as the connotation suggests, *zwickelbier*

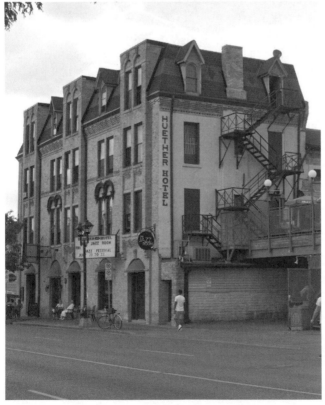

Above: The spigot, or *zwickel*, for a barrel would have worked tolerably for gravity-based pint pouring. In service, the back of the cask might need to be raised. *Courtesy of Black Creek Pioneer Village.*

Left: The Huether Hotel in Waterloo, which dates from 1855, remains one of the only Victorian breweries in Canada with functioning production facilities. *Courtesy of Malcolm Armstrong*

is drunk without a period of aging. That seems ideal for a burgeoning settlement thirsty for a taste of their homeland. It would also have allowed for a decreased production cycle, of which both brewer and public would have been glad. Rebscher's son, Wilhelm, holds pride of place as the second brewer of lager in Canada. He is listed in the 1836 census by profession as brewer. It's likely that he apprenticed at his father's brewery until deciding to strike out on his own. In 1842, he founded and operated a brewery that he continued until his untimely death in 1856.

The site of Wilhelm Rebscher's brewery, which is now the Huether Hotel, illustrates an important point about brewing in Waterloo Township that separates it from the rest of Upper Canada. Brewing in Waterloo Township was a dynastic affair for all of the families involved. Wilhelm Rebscher's property was purchased by the Huether family upon his death, and a stately Victorian edifice was erected on it that served as the finest hotel in the region. Adam and Christopher Huether's Lion Brewery was located out back. Any doubt about the presence of lagering facilities on premises can be assuaged by simply looking at the vaulted storage cellars, which, in winter, would have served the Baden-born Huethers admirably.

The third generation involved was Christopher Nicholas Huether, who joined the brewery in 1890. When his father passed on in 1898, he was given the option to purchase the brewery on the first anniversary of his father's death. Unfortunately, an outstanding mortgage meant that the brewery went to auction and was eventually purchased by Theresa Kuntz, the wife of their largest local competitor. This means that at one point or another, every dynastic brewing family in nineteenth century owned the property.

David Kuntz was likely the most successful of the first-generation brewers in Waterloo. This is due in part to the prodigious set of talents that he possessed. He was trained as a brickmaker and as a cooper in addition to having brewing as a skillset. Legend has him building his brewery out of bricks he fired himself and selling his beer out of a cask he had fashioned on the streets of Waterloo. We can only assume that he built the wheelbarrow that carried it as well.

David was not alone. His brother, Jacob, came into business with him at the Spring Brewery at the intersection of King and William. In a move showing some foresight, they also purchased twenty-eight acres to grow their own grain and hops. Jacob would eventually move on to found a brewery in Carlsruhe to the north in Bruce County, anticipating the direction of the next wave of German settlers who would fill in the land to the Lake Huron shores.

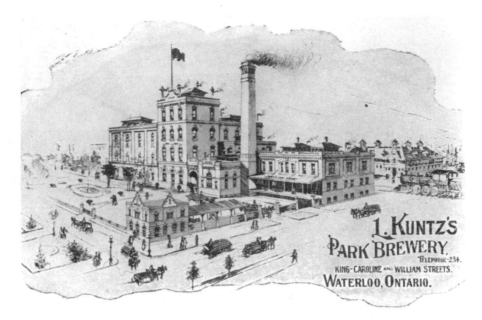

The Kuntz Spring Brewery is notable for two features. First, the tower brewery structure is representative of brewing in the mid-Victorian period. Second, its combined approach to the market includes both rail and horse-drawn wagon. *Courtesy of Waterloo Public Library.*

This image of the Labatt plant in Waterloo from the 1980s displays the longevity of the Kuntz Spring Brewery. *Courtesy of Waterloo Public Library.*

The Kuntz Spring Brewery did extremely well, providing the means for renovation and expansion into a Waterloo plant that would eventually produce ninety thousand barrels per year before prohibition. It also provided capital for the expansion of wealth within the family. In 1871, David Kuntz would move to Hamilton to set up the Dominion Brewery for his son, Henry Kuntz. Hamilton was a veritable hotbed of lager brewing before that time, as well as one of the first places in Ontario to host establishments used exclusively for the purpose of drinking lager, typically known as lager bier saloons.

Although we do not know the exact date of its founding, the book *Pen and Pencil Sketches of Wentworth Landmarks*, published in 1897, provides us with the information that a brewery had been in operation in Hamilton fifty years prior, founded by a German named Muntzeimer. It would subsequently become known for its proximity to the Crystal Palace, opened by Edward, Prince of Wales, in 1860 in honour of Queen Victoria. It was a sign of the rapidly changing face of the province that the beer gardens were favourites of the off-duty soldiery (predominantly British).

It is frequently related that lager reached the people of Toronto when Eugene O'Keefe started brewing it in 1879. This is an erroneous assumption. Lager enjoyed burgeoning popularity, as the *Globe* noted in 1858:

> *As we understand it, there are several things in its favour; the first is that it is not intoxicating, or at least it cannot be taken in sufficient quantities to produce inebriation. Again, the pure article is derived from malt and hop only, and is sufficiently bitter to make it acceptable to the stomach and palate, while as a thirst quencher it has, perhaps, no equal. By strong beer drinkers, it is invariably pronounced wishy-washy, on first acquaintance, but where there exists no morbid appetite for alcoholic stimulant, a short acquaintance universally makes friends.*

The article goes on to reference Leopold Bauer of Hamilton as the "Prince of Canadian Lager Beer Brewers." It spells out in plain language the intricacies of brewing lager, extolling the virtues of the large vaults beneath Bauer's Ontario Brewery and the necessity of brewing in the winter. It draws, for the purpose of communicating the concept of this exciting new beverage, a comparison in aging lager and stock ale.

There is a strange undercurrent of magical thinking in the press of the time about the beverages enjoyed by the German immigrants—that somehow Rhine wine and lager beer would not intoxicate. The *Globe* on

February 12, 1858, quoted the *New York Herald* on a court case in which the owners of a beer garden are defending themselves:

> *The question to be decided by this trial is whether lager bier is an intoxicating drink. If it is not it does not need to come within the provisions of the law. The penalty for each violation is $50…on the part of the defence a large number of witnesses proved, from personal experience, that any quantity could be drank without producing intoxication…Mr. Philip Kock testified that once, upon a bet, he drank a keg of lager bier, containing seven and a half gallons or thirty quarts, within two hours and felt no intoxicating effects afterwards. He frequently drank sixty, seventy, eighty and ninety pint glasses in a day.*

It is difficult to tell reading the report whether it is simply audacious beer garden owners lying voluminously to get out of paying a fine, or whether it is pointed satire. German immigrants were the butt of a number of jokes, based on the language barrier and their customs. It is Canada, after all, so the tension never devolved into rioting as it did in New York City. The German accent was made a point of fun in the *Globe*'s humour column in 1859 with the following comedic definition: "Drinkenoff makes a distinction thus: 'Too much whiskey is too much, but too much lager beer is shoost right.'"

You might be wondering by now what a night out in Canada West would have looked like if you were a beer drinker. If you were in a relatively rural location, the tavern might operate on rules set out in the township by-laws. Generally speaking, the rules were fairly straightforward and, to a modern audience at least, not particularly constrictive. Here is a relatively short list of the conditions you would be expected to abide by in Hardwood Creek, north of Kingston:

> *1) No book of seditious or immoral tendency to be read or discussed*
> *2) No assembly of persons for unlawful confederacy*
> *3) No playing with cards, dice, or any gambling*
> *5) No drinking to intoxication or drink to anyone already intoxicated*
> *6) No one in the House on Sunday except as regular boarders and no drinking*
> *7) No harbouring of smugglers or dealers in forgeries or counterfeit coins, or common prostitute, or "immoral, turbulent, disorderly, drunken person"*
> *8) No profane swearing, obscene language, disorderly conduct or assemblies with banners or symbols before or after an illegal procession*

These conditions are quite sensible. Rules 1, 2 and 8 may well have been influenced by the meetings of the rebels in 1837 at the Doel Brewery and Montgomery's Tavern—given the context of the times, it would hardly be surprising. Rules 3, 4 and 5 clearly dealt with the kinds of behaviour that would be likely to, in combination, lead to a brawl. Rules 6 and 7 were more repressive from the standpoint of civil liberties, but at the time, it was a town of seventy brave souls, and they were all on the same page. In case you were wondering, the beer was probably produced in the tavern or carted in from down the road in Sydenham.

Both men and women would be welcome in taverns. In the majority of cases, if they were customers of the establishment, they would most usually be present together. This was not always the case. A record from Robinson's tavern in Prescott, Ontario, from 1847 had the Widow Wilson lodging for a fortnight in November and running up a tab of fifty-six pints of ale during that period. While this might not have been completely common behaviour for the time, the duration of the stay suggests that it did not cause consternation even in the predominantly British Prescott.

As we have seen, the selection of beer that would have been available in a town of reasonable size would be entirely dependent on the makeup of the population and the quality of the roads leading to the town. The farther away from a major trade route you were, the more dependent you would have been on a local brewer. As a condition of the short amount of time settlements had existed, those that had been established longest typically had the best selection.

Kingston would have had quite a wide selection of ales due to the number of breweries and its prominent position at the top of the St. Lawrence for the forwarding trade. In an ad in the *Kingston Daily News* from October 7, 1862, Mr. McRae of Brock Street had plenty of barrels of the empire's finest Guinness, Barclay and Perkins, as well as Allsopp beer, along with a range of imported sherries, ports and brandies. There were twenty-five barrels of Guinness's Dublin Porter on offer among the pipes of port, chests of choice green and black teas along with locally distilled and Islay whisky.

Hamilton, one of the Province's oldest settlements, was one of the most diverse due to its role as a trade hub and embarkation point for newly arrived immigrants. Hamilton would not have much call for imported product since its local breweries produced beer in a wide number of styles, including the lagers preferred by the locals. Toronto, as a bustling and relatively sophisticated metropolis, had a fine selection of beer both in bottles and on draft a decade

before Confederation. Were you to find yourself standing at Yonge and King in 1858, you had options. If you preferred a class establishment, you would almost certainly plump for the Vine Saloon, owned by Harry Hogben. It was directly across the street from the *Globe*'s offices, so it would be full of the sort of hacks later called journalists. His selection of beverages ran the full gamut up to Old Tom Gin and Ben Nevis Scotch. The upper floors contained smoking rooms and an oyster bar. Hogben even subscribed to *Bell's Life in London*, so you'd be able to keep up with the sporting news. If you get bored, he had imported a bagatelle board from London.

The selection of beer was none too shabby, either, although it was import-heavy. On draft were Allsopp's and Bass Pale Ale, direct from Burton on Trent. There was Guinness Dublin Stout, but if you didn't care for that dry, roasty character, there was Barclay's Extra London Porter from Southwark. Those were also available in bottles if you wanted to take some home. The local option was from Toronto's Davies Brewery, a Sparkling Cream Ale. Even in a staunchly British establishment, there was "Buffalo Lager Beer in high condition." Harry Hogben aimed to please, even if he had to pay import duties to do it.

If you were in a slightly more boisterous mood, you might find yourself in one of the newfangled lager beer saloons that were popping up across the downtown. There was one over on Adelaide Street across from the courthouse and run by Mr. Kuntz (no relation to the Waterloo Kuntzes), but it wasn't always open. He and the magistrate seemed to have had periodic disagreements about whether you needed a license to sell lager, or whether it was acceptable to sell it on a Sunday. Given his location, one would have thought that some compromise might have been in order.

If you were feeling really bumptious, then Warner's Lager Beer Saloon at 92 Yonge Street was the place for you. It was partnered with the Walz Lager Brewery over by the Don River. Frederick Warner was a character, and like Kuntz, he didn't seem to believe in the need for a license to sell beer. Warner made the papers periodically for assaulting his customers. He was short-tempered, having once badly beaten his tailor in front of the customers during a dispute over a pair of pants. He made a good enough living to open the Rosedale Estate as pleasure gardens in the summer of 1863.

Warner surprised everyone one evening in September 1863 by disappearing in the middle of the night with his "wife, who was of colossal proportions, his billiard tables, piano and the greater portion of his furniture." The *Globe* reported that he had managed to convey all of his possessions to a steamer bound for America as a result of "a charge of

seduction about to be introduced into court by a young girl who was a servant in Warner's House." For pure human drama and a cold stein of lager, you couldn't beat Warner's House.

As Upper Canada approached the decade of Canadian Confederation, it entered a golden era that lasted more than one hundred years. It was filling up with new immigrants and generations of established residents. Tensions with the United States were largely in the past, and the economy strengthened year by year. What started with the controlled society of the era after the War of 1812, with its conservative hierarchy and homogeneity, had become a more complex and democratic community. The variety of beer exploded with the immigrants who filled out the townships and cities. In the coming era, this variety was challenged by new technological and business innovations that would change the brewing industry irrevocably.

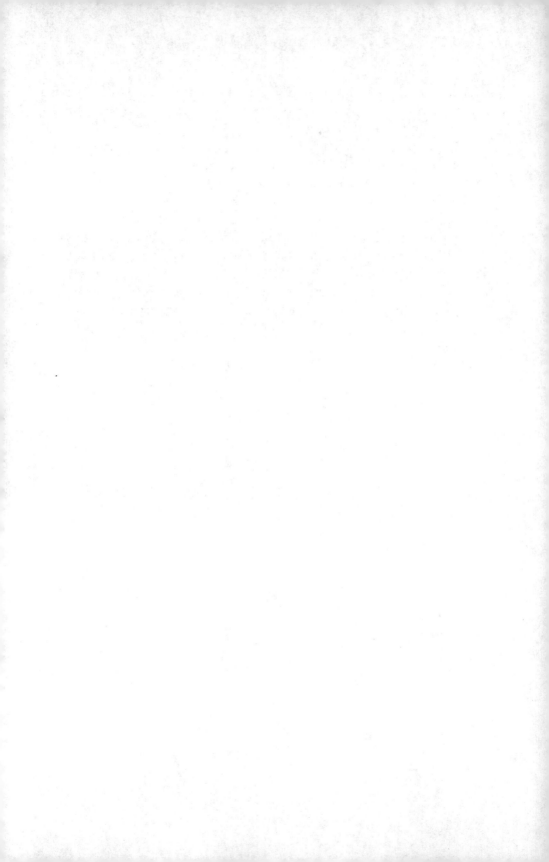

CHAPTER 4

VICTORIAN EXPANSION AND
INDUSTRIAL BREWING

1860–1900

O nc might be forgiven for thinking that the history of brewing in Ontario should have closely mirrored the history of the whole of Canada. There was one specific date that set the course of Ontario's brewing history in the mid-century, and it had nothing to do with Confederation. If you hadn't subscribed to the *London Free Press*, it is possible that you would have missed the following paragraph on December 29, 1858:

> *THE SARNIA BRANCH—The first passenger train on this road arrived here yesterday fore-noon. There were a number of passengers from Sarnia and the other stations along the route. The merchants of this city will find this road a great convenience, as it will enable them to compete with their Detroit friends in supplying the Sarnia people with those commodities purchased in the eastern markets. A large quantity of freight was yesterday shipped for Sarnia, among which was 30 barrels of beer and 50 dozen of ale, from the celebrated brewery of Mr. Labatt of this city.*

Just before the New Year in 1859, the rules changed. Beer remained heavy, but the roads no longer mattered.

John Kinder Labatt was almost certainly not the first brewer to ship his product by rail in Ontario. This brief article illustrated a number of the driving factors that would shape the Ontario beer market in the latter half of the twentieth century. Rail defeated distance. Suddenly, a town just over one hundred kilometers away from London became a regular fixture in Labatt's sales

territory. Not only did this provide Sarnia (a city without a brewery of its own at the time) with a constant supply of fresh beer, but it also discouraged Sarnia's residents from purchasing beer across the river in Port Huron, Michigan.

In one gesture, no doubt simply meant as celebration of a newly completed rail line, we have technological advancement, capitalist expansion and economic protectionism. It was also one of the first successful staged public relations events for an Ontario brewery. It made the paper, after all.

THE RAILWAY

Rail did not spring up fully formed in Ontario, or indeed anywhere on the North American continent. It was typically envisioned as a primarily local service that would be beneficial to the points that it created a path between, but the owners were not insensible to the rapidly growing network. If you take the Toronto and Guelph Railway as an example, the report of the board of directors in 1853 (its second year of operation) made it clear that the members were extremely proud of the work that they have accomplished; however, an amalgamation with the Grand Trunk Railway would result in their line expanding into the distance as far as Sarnia and possibly Chicago beyond.

The Grand Trunk Railway included several smaller companies at the time of its creation in 1853. By 1859, it would span just over eight hundred miles to Portland, Maine, from Sarnia, Ontario. In 1856, the line along the St. Lawrence and Lake Ontario to Toronto was completed. It reduced the amount of time spent in travel between Montreal and Toronto to fourteen hours from just over two days by steamboat. Southwestern Ontario had its own rail company in the form of the Great Western Railway. The Great Western focused initially on the creation of shorter lines that would connect what we now think of as neighbouring communities. In 1853, it created two lines: one from Hamilton to the suspension bridge at Niagara Falls and another from Hamilton to London. The next year would see the London line expanded to Windsor.

By 1855, a branch line had been constructed from Hamilton to Toronto. For the time being, Toronto was an afterthought to the Great Western Railway, which was looking to take advantage of the increased trade in raw materials with the United States brought about by the sudden lack

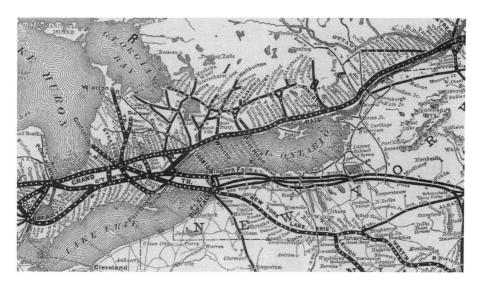

This detail from the Grand Trunk Railroad map of 1887 highlights the strictly regimented distance between stations and the orderliness that had been imposed on what was a wilderness only fifty years prior. *Courtesy Wikimedia Commons.*

of tariffs. Inevitably, as rail became the dominant mode of travel in Ontario, additional lines were created in order to connect small farming communities and market towns that had originally depended on water routes for their prosperity.

Every point on the main lines between Windsor and Cornwall had been laid out based on access to the lakefront and rivers that the province's original surveyors felt crucial. If you leaf through the maps chronologically, the advancing cables of steel provide a sense of well-regulated arterial structure to a province that is becoming an economically dominant organism. A look at the Ontario rail system by the end of the century, especially in comparison to those in Michigan or Ohio, puts one in mind of the unofficial national motto: "Peace, Order and Good Government."

The timeline of expansion into branch lines has a special significance for the brewing industry in Ontario. From a relatively early point in the 1850s, shipping beer by rail became a possibility. Because of the manner in which the two main lines were situated, this new technology disproportionately benefited urban brewers. London became a stop on each rail system, as did Guelph and Toronto. Hamilton was a hub dictating traffic in every possible direction. Breweries that were astute enough to avail themselves of the opportunity would thrive.

It should be stressed that market dominance did not come immediately. The initial generation of settlement of much of Ontario was still occurring by the time the railroads begin to stretch across the province. By 1862, there would be 155 breweries within the province of Ontario, a number that is suggestive of the realities of brewing locally and without refrigeration. Each town large enough to support a brewery of modest size did so. Thanks to the advent of rail, that situation would quickly become untenable. By 1902, only 62 breweries had survived.

MASS AGRICULTURE

With the steel ties of the railroad inexorably binding together local economies, some things would change forever. While Ontario is generally incredibly fertile, different districts produced crops at varying levels of quality. Unlike today, when we think of the prairie provinces as being the breadbasket of Canada, Ontario was largely independent in terms of the production of grain in 1860. Grain exports were an important driver of local economies. England's Corn Laws had long since been repealed, creating a situation in which a considerably higher price could be demanded by the colonies for high-quality wheat and oats. These prices did not vastly fluctuate from year to year given England's size and demand for each crop in the face of increasing population. Wheat would be a stable choice for a farmer in Ontario, presenting a steady yield per acre and a reasonable return on cautious investment. Barley was a more speculative crop with unpredictable outcomes on a year-to-year basis. It would provide some return on investment, but how much was left in some ways to chance. The quality of the barley afforded by the soil could make a substantial difference.

The area surrounding the Bay of Quinte in Hastings and Prince Edward Counties was uniquely positioned to take advantage of an extraordinary set of circumstances. Geographically, they were within reach of Oswego in New York State, a barley-hungry town that would supply grain to brewers throughout upstate New York. Economically, the Elgin-Marcy Treaty of 1854, which ensured reciprocity of trade, meant that there were no tariffs in place on grain shipped across the lake. The American Civil War created a truly significant demand for the product. In 1862, President Lincoln passed an

excise tax on whisky, effectively increasing the price per bottle tenfold. As beer remained untaxed, production and consumption would increase dramatically. When you add to the mix the general loss of labour and production capacity to the Civil War and the expansion that continued westward in spite of it, it is clear to see why barley became Ontario's cash crop.

In 1863, the year after the declaration of the excise tax, we have some idea of the quantity of barley exported and from whence it came. Toronto listed 288,108 bushels of barley, all of which was shipped directly to Oswego. At 48 pounds to the bushel, that comes to just under 14 million pounds of barley. Prince Edward County put that figure to shame, having harvested and exported more than double that amount for the duration of its "Barley Days." One need only stroll through residential neighbourhoods in Picton to see the lasting economic effect. Its showpiece Crystal Palace in the fairgrounds is a testament to the wealth that barley created.

Even after the reciprocity treaty ended in 1866, the quality that Ontario's barley harvest ensured meant that Americans would continue to seek it out even with a mild tariff imposed. On average, between 1882 and 1890, the total figure for the province was 750,000 acres planted, producing 20 million bushels. The average price per bushel in a good year might climb as high as a dollar. It was not until 1890 that the McKinley tariff would prove catastrophic for Ontario's barley farmers. The tariff of thirty cents per bushel nearly halved the asking price and largely destroyed its profitability as a crop for export to America. Some discussion was had in the *Globe* in May 1890, contemplating the possibility of switching to a separate crop of two-row barley for export to England—a statement that came after acknowledgement that only half as many acres would be planted that year. The majority of the 1890 crop would end up as fodder for animals.

AGENCIES

Prior to the advent of rail, each brewery needed a system of distribution in order to make its business viable. There was always the possibility of short-distance delivery by wagon within a certain circumference of the brewery, but this was an untenable solution beyond a certain distance due to the logistics involved. The obvious solution was to transport beer using existing services as agencies.

In the case of a number of urban breweries—those with the ability to take advantage of the limited advertising that local newspapers would provide—arrangements could be set up with cartage firms or depots. The depots need not have been a great distance from the brewery. In the case of the Spadina Brewery in Toronto, purchases could be addressed to its depot on Queen Street, much closer to a more populated area. Orders could be filled in lots of a dozen bottles, a quantity that has remained stable to this day.

Even before the advent of rail in Ontario, there had been some distribution through cartage firms to remote towns. Breweries were typically not yet large enough to be able to negotiate the minutiae of local sales on their own behalf, and as such they would entrust their business to a single representative. Typically, this might be the owner of a dry goods or grocery store. Aside from taverns, there was not enough variety to warrant specialty stores for beer. As breweries grew in size, they would ship to a larger number of towns, resulting in a situation where a single agent might represent several different breweries.

With a rail system solidly in place, it became possible for breweries to take advantage of one of the largest and most orderly systems of transport in North America. For one thing, the quantity of beer shipped changed dramatically between 1860 and 1900. Instead of being able to simply fill bottled orders for a nearby agent, beer could be shipped for hundreds of miles in barrels or hogsheads and bottled at the other end of the line. The reduction in transit time meant that, even if unrefrigerated, there would be little loss of quality due to the high turnover in market towns with sizeable populations.

Before we detail the rise of the giants of brewing in Ontario, some consideration should be given to those smaller breweries that sprung up midcentury. In a history of this length, it is impossible to enumerate all of the breweries that existed. Some small-town brewers may well find themselves without equal representation in these pages, but then, not all breweries are created equal. Let us nevertheless press forward with a brief tour of the province's roll call at the point of decline in 1870.

Eastern Ontario and Ottawa were relatively slow to develop a number of breweries representative of their populations. In Ottawa itself, there was George Stirling's Dominion Brewery on the Ottawa River near St. Patrick. It's within earshot of Notre Dame and has been happily occupying its spot since 1851. It had pride of place near the market, making it competitive with the other two large breweries. The Rochester-owned Victoria Brewery was the oldest of the established breweries in the nation's future capital. John Rochester helped his older brother, James, found the brewery in

1839 at the age of seventeen. It was located out on the Lebreton flats near the Chaudières. The Rochesters, as a clan, owned a surprising number of businesses and were, as a result, massively politically connected. John Rochester was actually selling the brewery to his older brother, James, so that he could concentrate on being mayor. It was older, and while active, it was not producing a huge quantity of beer.

The Union Brewing Company was the coming thing. Founded in 1865, it was initially owned by a partnership, but the man doing most of the work was Harry Fisher Brading, who was a brewmaster by trade. In 1867, Brading bought out John Atwood, leaving him partnered with Henry Israel. Brading and Israel were located in a position near Sparks and Wellington to service Ottawa proper, but they were also near the fringe of the city and could take advantage of rural markets and the particularly thirsty lumberjacks and log drivers.

Along the St. Lawrence, Brockville was more or less an open market. Bowie and Company set up shop in about three years before becoming Bowie and Bate in 1877. Cornwall was similarly underserved, but no one was going to rectify that problem for a while. It is on the St. Lawrence, so it was not like it didn't have access to beer from other places. Prescott was a different matter, due to the presence of Ogdensburg across the river. Ogdensburg was an important railway junction, and there were a number of lines that passed through it. Prescott had been connected to Ottawa by rail since 1852, and it was a transfer point for the Grand Trunk. As a result, it was a very sensible choice as a location for a brewery. Robert and Ephraim Labatt purchased the Prescott Brewing and Malting Company in 1864 from their older brother, John, who had gone into business with George Weatherall Smith. Smith relocated temporarily from Wheeling, West Virginia, when the question of secession made Wheeling's future uncertain.

John McCarthy and James Quinn had just opened a place of their own about a mile west of Prescott. They were brewing two beers, differentiated by the brands "XX" and "XXX," in a steam-powered tower brewery that ought to have been the envy of the industry. McCarthy knew what he was doing in terms of brewery appointments. He had been working in brewing or distilling in Prescott since he was twenty and fresh off the boat from Dundee. The cellar had room for two thousand barrels, and the beer was comparatively low in alcohol for the time, so they were churning through that capacity.

In Kingston, George Creighton's Frontenac Brewery was tooling along, but it was destined to serve the local market due to its small size. The

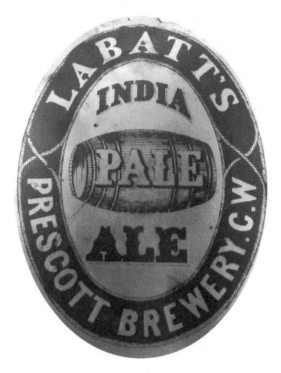

Later in the Victorian period, as Labatt's labelling and branding further evolved, the India pale ale label was designed, replete with medals and arrowhead trademark. Despite attempts to create a unique brand, Labatt did have imitators. *Courtesy of Molson Archives.*

cellar seemed to hold about 150 barrels. Joseph Bajus down on Wellington Street was slightly more ambitious, having added a three-story tower to the premises when he purchased it in 1861. If he was not brewing lager initially, he would be shortly. Hayward and Downing had their brewery on the other side of downtown quite near Queen's University. According to the style of the time, they went with a railway motif under the name Grand Trunk Brewery. It's likely that they supplied the railway itself since Kingston was the lunch stop. Kingston had a large enough local population, but it had lost its primacy as a brewing centre and would face numerous closures before the turn of the century.

Farther west, in Prince Edward County, there was the Pickering Brewery in Picton. It was basically just large enough to support the town. Belleville had the Roy Brewery on Front Street—two of its competitors went under in the 1860s. The Hastings Brewery lasted four years, while the Moira Brewery existed for slightly more than a decade. Within a few years, William Severn

would open a brewery, but at the time, if you were in Belleville, you were drinking Roy's.

In Cobourg, James Calcutt has sold out to the MacKechnie brothers, who renamed the establishment the Victoria Brewery. James Calcutt himself had moved west to Port Hope, and his son, Henry, had moved to Peterborough, an area that had been waiting for a brewery of some size. James Calcutt's competition in Port Hope was Thomas Molson, but the focus of his plant was distilling, and it closed in 1868. West of Peterborough, there was the Victoria Steam Brewery in Lindsay, an unnamed effort in Cannington and a brewer in Orillia by the name of W.W. Jackson. Barrie was more prosperous, and Robert and Thomas Simpson had been brewing since 1851 at their Simcoe Steam Brewery, although Robert had been brewing in the area since 1836. The Anderton Brothers set up shop in 1869 less than one mile away.

Around the southern shore of Georgian Bay and Lake Huron, there had been some activity. Collingwood had a brewery for two years in the early 1860s. Owen Sound had Henry Malone making a go of things for twenty years. Kincardine, Bayfield and Seaforth all had people whose sole occupation was listed as brewer. Chatham was currently without a brewer due to an inexplicable decade-long closure of Henry and Joseph Slagg's Chatham Brewery. Sarnia had the Sarnia Brewery, and Sandwich, near Windsor, also had an eponymous brewery.

The vast majority of these breweries would disappear before the turn of the century. There are numerous reasons why they were prone to failure. Truth be told, fire claimed as many breweries as temperance ever would. Breweries that had sprung up quickly in order to serve a community would usually have been of wooden construction, and even a stone structure was no guarantee of safety. It might have been as simple as a horse kicking over a lantern in the brewery's stables. It might have been a young employee sampling your wares instead of watching the malt kiln; perhaps the sacking used in the process caught while unobserved. If you were particularly unlucky, an act of God might lay waste to your brewery and the entire neighbourhood surrounding it, as it did in the case of Ottawa's Victoria Brewery and the Lebreton Flats in 1899.

On a long-enough time frame, it was far more likely that a brewery would catch fire than not. The only question would be the extent of the damage. While brewers certainly carried insurance, it was typically the buildings and equipment that would be insured. Due to the extraordinarily rapid expansion of brewery volumes during the period, it was almost a certainty that the policy would come nowhere near covering the ingredients in process

or the beer in storage. Even if the policy were up to date, in some cases the brewer simply did not have the will to rebuild. In the case of the Kensington Brewery in London, this was certainly true. Robert Arkell's insurance covered barely half of the loss, and despite the comparative success he had enjoyed, he never rebuilt.

Brewing is a fundamentally generational business. There are instances of dynasties like the Labatt, Molson or Kuntz families—situations where the ownership has been kept largely under family control. These are the exceptions. Typically, the business does not advance to a second generation. The brewery will simply begin and end with the founder. In many cases in rural Ontario, the brewery would be profitable enough to ensure a comfortable living, but given the amount of opportunity available, it might not have seemed the best bet for someone in a family's second generation.

To keep an inherited brewery open at its current size would mean that your production volume would remain the same. For that reason, the distribution area would not increase. Even with additional volume, establishing the agency contacts necessary to sell beer in other towns was laborious. Barley, as we've seen, could vary greatly from year to year in price, meaning that margins might be unpredictable. Further, with each passing year, there would be more breweries from other markets attempting to acquire agents nearby, entering the local market on their terms with a head start because of their rail connections. Competing would require not only capital for expansion but also enough drive and interest in the business to sustain a brewer's ambition.

THEIR TERMS

While the first breweries in Ontario might have been based out of taverns or homesteads, and the second wave involved professional brewers making enough beer to satisfy local demand, the third wave in the 1860s and 1870s was gargantuan by comparison. The breweries were massive, with huge facilities and capacity that boggles the mind relative to the population of the province at the time. In 1861, the population hovered around 1.4 million people, and that figure would increase by 50 percent before the turn of the century. Ontario's breweries produced vastly more beer than was needed to slake their thirst.

It is at this point in the history of Ontario that names emerge whose legacy has spanned a century. Labatt, Carling, O'Keefe and Sleeman are all brands with which we're familiar, and it was the actions of these brewers in the last decades of the nineteenth century that have ensured the survival of their reputations. The commonality that they seem to share is a vision for the scale of enterprise that would be required to ensure their continued success, as well as their willingness to face the financial risks that went hand in hand with the attempt.

In the case of the Carling Brewery, the hand guiding the tiller was John Carling, who, along with his brother, William, purchased the brewery from his father, Thomas, in 1849. The success of his brewery mirrored that of his political career. First elected as a local politician sitting on the school board of London, he worked his way up to become receiver general for the Province of Canada and, subsequently, Ontario's commissioner of agriculture and public works. Under John A. MacDonald in 1891, he was named minister of agriculture. During this period, he instituted a number of Ontario's experimental farms and oversaw the construction of several important public buildings in London. John Carling was a man who saw the potential of building for the long term, and he certainly understood that having his finger on the pulse of the nation's business was good for his own.

While the Carling Brewery had never been a small affair, it was comparatively ramshackle. It comprised several buildings on Waterloo Street that had been added to as the need arose. By 1860, it was the third-largest business in London, producing 3,600 barrels of beer annually. That figure would nearly triple by 1867, ranking it among the largest breweries in the province.

Seeing the need for additional room in which to grow, the brewery began construction in 1873 of a state-of-the-art facility with a much larger capacity. The new location at the corner of Ann and Talbot had access to a spring that produced sixty thousand gallons a day. It could malt eighty thousand bushels of barley per year (fully one-third of that exported from Toronto by boat). Rather than horsepower, the brewery was rigged for steam and had an annual capacity of seventy thousand barrels, enough to serve every resident in the province ten pints. This was an optimistic estimate of the company's potential and came with a hefty price tag of $100,000. A separate lager brew house was added in 1878, increasing the capacity a further fifty thousand to sixty thousand barrels. Communications throughout the buildings were handled by a newly installed telephone system—having been invented in Brantford two years earlier.

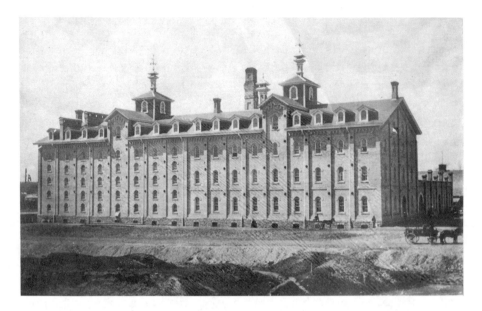

This 1889 image of the Carling Brewery in London, Ontario, was taken after the plant's renovation in the wake of a devastating fire that left only the shell of the building intact. *Courtesy of Toronto Public Library.*

On February 13, 1879, disaster struck when one of the brewery's four new malt kilns overheated and created a catastrophic blaze that would destroy all but the bones of the new brewery. William Carling subsequently passed on as a result of pneumonia contracted while attempting to put out the fire. In addition to the personal tragedy, the damages neared $250,000, a figure that did not even cover the stock contained within the brewery, let alone the building itself.

The Carling brewery underwent massive reconstruction efforts, possible due only to the clever design that left the outer walls and brickwork intact. By the first of May, the brewery was up and running again. One cannot help but feel that the speed of the reconstruction had much to do with the esteem in which the citizens of London held Mr. Carling. It is also likely that his forays into the political arena eased his access to a loan from the Bank of British North America. Regardless, the effort was truly astounding. A phoenix motif was adopted in illustrations of the brewery for years afterward.

By the end of the century, Carling would have a complete network of agents throughout Ontario, but additionally, it would have established sales in every major regional hub accessible by rail in Canada. Attempts to expand

into the United States would see the establishment of a short-lived brewery in Cleveland and agents in Detroit. Once a year, there would be a shipment of amber ale and porter to Hong Kong. It is difficult to say whether there was a legitimate demand, or whether it was in part a diplomatic gesture from Canada's minister for agriculture.

The story of Labatt's success is remarkably similar, even if it is on a slightly smaller scale. The original Labatt Brewery succumbed to fire in March 1874. Nothing could be salvaged, and the insurance did not even cover the malt that was on hand for the spring brewing season. Having expended the effort to build a sales network, rebuilding, if it could be accomplished quickly, was a comparatively safe bet. John Labatt would run through his personal savings and investments and a significant portion of the family's fortune, which was in those days under the control of his mother.

At the time of Confederation in 1867, Labatt brewed about half of the volume that Carling could boast, but after the construction of a new and efficient brewery, Labatt could manage thirty thousand barrels a year, with facilities to produce far more malt than would be needed for that capacity. What stock there was would take advantage of the comparatively new technology of refrigeration. He would trade in malt across Canada as far away as Halifax, perhaps foreshadowing the relationship that the Labatt and Keith's breweries would share more than a century later.

Where existing facilities for brewing stood, improvements were made. Where brewers dreamt of success, giant facilities sprang to life. The William Street Brewery in Toronto stood on the west side of University Avenue, very close to Dundas Street. For sheer scope, it was the largest malt house in Canada. Built by John Armstrong Aldwell in 1859, the William Street Brewery had an initial malting capacity of sixty thousand bushels a year, with the ability to brew nineteen thousand barrels a year. Additionally, it was one of the first Ontario brewers to employ its own travelling salesmen in place of agents. The *Globe*, writing in 1868, was not insensible to the massive capacity:

> *Their manufacture enters largely into competition with the Montreal ales in that city, while on the day of our visit an assortment in bottles capable of making a good sized town hilarious, was being shipped to the Bruce Mines, the manufacture of all of this is accomplished by machinery, and manual labour enters less into the calculation of cost than in many smaller establishments of a similar kind.*

In 1868, its new six-story malt house was prized not only for its utility but also for its attractive and efficient architectural features. Previously, malt houses would have employed direct-fired kilns. In the case of Aldwell's malt house, the furnace was in the basement, and the five-story kilns were heated by a series of vents and flues. The total capacity annually was 220,000 bushels of barley. The 10.5-million-pound yield made it the second-largest malt house in North America behind Greenwood's in Syracuse, New York.

Aldwell was a savvy businessman. To give some idea of the scale of his ambition, in 1871 he was involved in an arrangement with the City of Toronto to open a sugar refinery. It was so large a project that the city agreed to exempt it from taxes for a period of twenty-one years. Sadly, Aldwell did not end well, passing away in September that year at the tender age of forty-seven. Had he lived, it's likely that the face of the brewing industry in Ontario would have a different complexion. As it was, the concern became the Toronto Brewing and Malting Company in 1874—a company prodigious in its own right.

While sheer volume was an indicator of progress for breweries in Ontario, progress could similarly be measured by the technology in use. Equipment for scientific measure of various facets of the brewing process was available by mail order through newspapers in the 1840s. By the 1880s, the province had a supremely efficient rail system, telegraph and telephone and acted as a cultural crossroads between Britain and America. Ontario was at the forefront of technological development, even managing in some instances to contribute. It certainly did in the brewing industry.

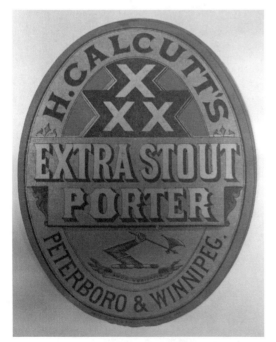

The Calcutt Brewery of Peterborough provides an excellent illustration of the changing times. The brewery retains its crest and motto despite the change from Extra Stout Porter in the 1890s to Trent Valley Lager after prohibition. *Courtesy of Molson Archives, Jim Maitland.*

George Sleeman of the Silver Springs Brewery in Guelph was awarded a patent in 1873 for a jacketed fermenting tub that could control the temperature of the beer inside by regulating the rate of flow of water around it. It was a vast improvement on the overcomplicated device that Kingston brewer Aaron W. Lake had patented just three years earlier. Henry Calcutt of the Calcutt Brewery in Peterborough held several patents, the most impressive of which is the 1893 patent for a particularly efficient flue boiler with increased surface area for faster heat transfer in the brew house. This was an improvement on his 1881 attempt to patent sparging as a technique.

Perhaps the most impressive innovation was that of Thomas Frederick White of Port Colborne, who in 1898 patented a design for a beer filter that was not substantially different from those in use today. It was seemingly an early version of a plate and frame filter that is doubly impressive for the reason that it was modular and could be expanded depending on the amount of beer to be filtered.

ADVERTISING

If the model for success in brewing in Victorian Ontario was to centralize production in a single enormous facility with all of the modern conveniences, the model was not a secret. While smaller brewers fell by the wayside, competition began to grow in markets across the province as large brewers competed in earnest for the first time. In market towns with rail access around the province, consumers suddenly had an overwhelming number of options available to them, where as little as ten years earlier, there had been only the local brewer.

The advantage of being the local brewer in a pre-rail Ontario was the fact that there was very little competition, and as such, there was no real need to differentiate one's product from other products. Newspaper advertisements prior to the growth of rail would typically advertise two facets of the business. The first was the fact that it was an ongoing concern at a certain address. The second was a short listing of whatever few types of beer might have been available. For a typical ale brewery, this would be an amber or pale ale and some manner of porter. In the case of adventurous ale brewers, they might go so far as to sell a blended version referred to as a half and half. Lager brewers typically sold one kind of lager.

The development of branding in the late Victorian period can be observed in the evolution of Labatt's labels. The first does not even name the brewery that has created it, focusing only on the type of beer contained. *Courtesy of Molson Archives.*

As branding progressed in the late Victorian period, Labatt's labels featured the brewery name. *Courtesy of Molson Archives.*

Within a period of twenty years, breweries were competing for customers in far-flung cities and towns halfway across the province. The largest brewers from Southern Ontario were shipping beer to Thunder Bay and Silver Islet as early as the mid-1870s, prior to Conrad Gehl's brief attempt at constructing a local brewery to service the miners. Gehl's brewery was seized in 1877 by the government for failure to first obtain a license to brew, but it was allowed to reopen after the fifty-dollar fee was paid.

Brewers were also competing with other messages and movements in society. The temperance movement was becoming a strong political force, with thousands of Upper Canadians taking the personal pledge. As temperance became a political movement, it took on prohibitionist principles. Church leaders and reformers lobbied for legislative action in the 1850s to allow a local ban on booze.

The Canada Temperance Act of 1864 confirmed municipal power to hold a vote on whether to go dry. After more than a decade of relative quiet, the city of Toronto finally voted in 1877, and detailed minutes were kept by a committee of those successfully campaigning for the "no" side. At one meeting, Eugene O'Keefe stood to speak on behalf of the drinking of light wines and beers. At others, tavern keepers objected to the claims of lawlessness, pointing out how other routes to drunkenness were far more problematic. A Mr. Waterhouse shared the example of "a case of wholesale drinking at a public boarding house, where 18 galls. of beer were brought in, and the result was, that in less than four hours, everyone of the eighteen boarders in that house was drunk, and the old woman in disgust threw the keg into the yard."

As temperance expanded, breweries and rail lines also extended their reach. One significant problem they faced was the way in which identification with the breweries lagged behind the new province-wide demand for their beers. For example, several breweries operated under the name "Dominion," including ones in Hamilton and Toronto. At one point, there would have been at least five breweries referred to as the "Victoria Brewery" across the province—a situation that would lead to confusion for customers should agency sales tick up. The need to differentiate products from one another in order to remain competitive led Ontario brewers to adopt labels increasingly colorful in both their language and design.

Brewers increasingly adopted trademarks that would make their brand stand out on the shelf. In some cases, these would simply be monogrammed initials, as in the case of the O'Keefe Brewery in Toronto. By the time Arthur Anderson took over the Victoria Brewery in Ottawa, the brand's identity

A portrait of the staff at the O'Keefe Brewery in Toronto near the turn of the century. *Courtesy of Toronto Public Library.*

had become a double *A*. The Grant and Sons Brewery in Hamilton would use the same superimposed monogram to identify its bottles.

More usually, a simple image would suffice. The Davies Brewery would use a five-pointed star in yellow and white to represent itself. The Walkerville Brewery in Windsor would use a series of stars and crosses. Ambrose and Winslow in Port Hope chose the less symbolic but more useful corkscrew as its logo. Cosgrave in Toronto would go with a stag or horseshoe—or, in later examples, a combination of both—before settling on what can only be referred to as a goofy-looking tiger. Several breweries would use the beaver as a symbol, which has persisted to this day in the case of the Sleeman Brewery.

Simply creating an identity for the brand was not enough. While brewers had always made different varieties of beer, the necessity of creating a memorable name for their products eventually led to creativity. Instead of simply producing an amber or pale ale, breweries were suddenly producing cream ale and crystal ale, sparkling ale and "XXX Diamond" pale ale. India pale ale was a certainty by this point in the nineteenth century, but

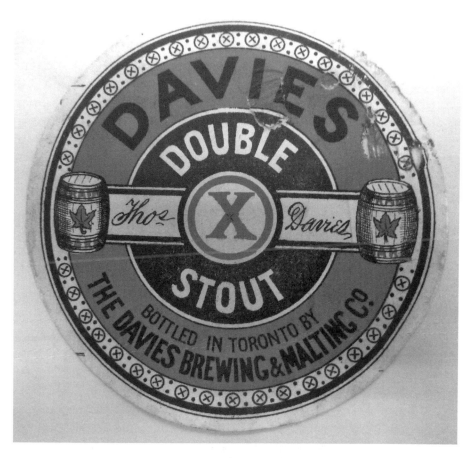

Thomas Davies's Double Stout featured a circular label with the maple leaf and barrel trademark. *Courtesy of Molson Archives.*

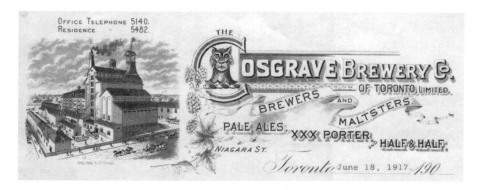

This detail from the Cosgrave Brewery's stationery displays its decision to stick with the styles of ale that it was used to well into prohibition. Also, note its ill-conceived tiger mascot. *Courtesy of Thomas Fisher Rare Book Library.*

O'Keefe produced an imperial pale ale. MacKechnie's Victoria Brewery in Cobourg was producing an "EXTRA HOPPED" pale ale. Walkerville produced a Canadian pale ale in a clear bid to take advantage of cross-border traffic.

It was no longer sufficient to put one's stout on the market as it stood. It required an identity, whether that be imperial stout, XXX stout, double brown stout or extra stout. In one wonderfully evocative example, the Davies Brewery in Toronto marketed a sable ale. It is likely that all of these beers were already being brewed by the time it was necessary to identify them with colourful labels. It is not as though there was a sudden burst of stylistic diversity in 1870. It was just that marketing had not been of as much value before that point.

In the last three decades of the century, brewers would define the strategy of marketing beer in order to better avail themselves of distant consumers. Some of the techniques are still in use and will be immediately identifiable to a modern audience. The first is simple and entirely understandable when one considers the amount of vibration beer would have been subject to as it was shipped by rail and the speed with which it would be consumed at the other end of the voyage. In order to prevent customers from accidentally being turned off their brand, breweries would apply notices that the bottle should be stored in an upright position for twenty-four hours before being decanted, carefully and without shaking. Clearly, the lack of filtration technology meant that some bottles would contain sediment as an ordinary part of the experience. Not only did this result in the best experience for the consumer, but it also portrayed the brewery as caring deeply about the quality of its product. It was an early form of built-in beer education.

A second technique that entered common usage was the declaration of the ingredients used in brewing the product. It should go without saying that the majority of breweries would have used only the basic ingredients: hops, malt, yeast and water. While rice would crop up as an adjunct for some breweries toward the end of the century, it cannot be thought of as exactly unwholesome.

A popular extension of this concept was to have a chemist analyze the product so that advertisements in newspapers could declare that the beer had no unnatural additives and was unadulterated in any way. This also had the benefit of casting aspersions on the competitors that had not thought it necessary to retain such a chemist. Taken to its logical extreme, the results were unsettling. The Rock Brewery in Preston would eventually claim to be "Brewed from the famous Spring Water. Pure and Free from Drugs and Poisons."

Thirdly, there was the inclusion of credentials. If the beer had won an award, it was in the maker's best interest to let the public know about it.

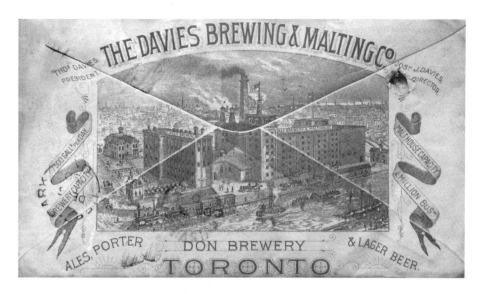

This envelope from the Davies Brewing and Malting Company in Toronto highlights the pride brewers took in their accomplishments. It lists the variety of products, quantity of malt and a production capacity of nearly ninety thousand barrels per year. *Courtesy of Thomas Fisher Rare Book Library.*

Labatt's India pale ale, for instance, incorporated the first two medals that the beer won at international competition directly into the label. There would be no way of mistaking its pride in its product.

Toronto's Dominion Brewery would note in the margin of the label for its India pale ale that it had been "awarded highest honours & medals at the North Central and South American Exposition New Orleans 1885 against Bass & other celebrated English Brewers." Why would the consumer even consider buying Bass when a locally produced beer had beaten it at a prestigious competition? Marketing it may have been, but there is the real possibility that Ontario's beer would have been of a quality comparable to that in England after only sixty years of industrial-scale brewing.

LAGER

Except for eastern centres like Kingston, by the end of the nineteenth century, lager would make up a quarter of the total volume of beer sold in

Ontario, although there is some reason to doubt that commonly accepted figure. There is the possibility that it is significantly lower than the real figure.

One of the difficulties in the regulation of the brewing industry in the rapidly expanding province of Ontario in the late 1860s was keeping accurate records in order for the government to collect the duty owed it. Given that the figures were collected annually, and that they were supplied by the breweries themselves, inaccuracy was a real concern. For one thing, brewery production would have increased on a yearly basis as the population of the centres around each brewery expanded. For another, there has always been the temptation for a business that is not being scrutinized to underreport its sales.

It did not help that some of the agents acting on the behalf of the government were grossly incompetent. In 1866 and 1867, two agents named Godson and Romain were tasked with an investigation into the sales figures of the lager breweries in Waterloo County. Suspicions had been raised when it became apparent that the total volume reported for the 1865–66 brewing season was 78,552 gallons of beer, or just over 2,450 barrels. This laughably low figure represented the total reported output for thirteen lager breweries in Waterloo County. The charge of fraudulent sales made it clear that a single brewery was selling more than half of that amount annually in the lager saloons of Hamilton alone. It meant that no one was paying any taxes.

The agents performed a perfunctory two-day tour of a handful of breweries in the county, taking testimony from brewers whose natural inclination would have been to lowball the figures. Even those dubious accounts vastly outstripped the reported volume. Upon declaring the allegations unsubstantiated, Godson and Romain were given a sound drubbing in the newspaper for their incredulous gullibility. This episode illustrated the fact that the sales of lager in Ontario at Confederation could easily have been five or even ten times as high as common wisdom would suggest.

There were many facets of brewing lager that could be advantageous to brewers. In terms of courting public opinion, lager was viewed as a beverage of temperance, which helps to explain the timing of its adoption. The passing of the Canada Temperance Act in 1878 meant that local-option prohibition was a possibility. This fact was not lost on Eugene O'Keefe, who had provided testimony at local-option hearings. He took out a full-page spread in the *Globe* barely a month after his lager and pilsner were introduced: "Messrs. O'Keefe and Co. contend that the benefits accruing to the country by the introduction of first class malt beverages cannot be over-estimated, and will tend more to the interests of TEMPERANCE than all the legal enactments and repressive measures that any Government may introduce."

The advertisement goes on to claim that religious dignitaries from Buffalo were of the opinion that lager was second only to religion in terms of restraining drunkenness and that the working-class population had been weaned off anything stronger. Not only is lager good for society, but the hops also come from Nuremburg! The brewer has twenty-five years of experience! Truly, it is the "Champagne of Malt"! It is so effective at curbing drunkenness that the brewery is prepared to sell fourteen thousand gallons on a day's notice.

Humbuggery aside, product analysis conducted by the Inland Revenue Department in 1910 suggests that the average strength of ale on the market hovered around 7.0 percent alcohol, whereas lager tended to come in between 3.5 and 4.5 percent. Given a similar production schedule, lager would be cheaper to produce than ale due to the smaller quantity of malt needed to produce the same volume of liquid. Additionally, any measure that might prevent the prohibition of alcohol was to be viewed by brewers as a good thing.

COMBINES AND ALLIANCES

After years of success, some brewers sought to leave their businesses behind to enjoy the benefits of the wealth that they had amassed. One critical problem they faced was how to move on from the brewery when they were effectively still governed by their founders. Two Toronto brewers, O'Keefe and Cosgrave, found themselves in court in the 1880s due to their reliance on the traditional business structure of partnership, which relied on the trust of individual partners and business associates.

Cosgrave & Sons was brought to court over a sales agreement. Patrick Cosgrave, the father, died in September 1881. A notice of a claim for $5,000 was served on the brewery in April 1882 based on a contract from years before. Fortunately for the brewery, the partnership (and therefore the obligation) was determined to have dissolved upon his death. However, the extended litigation proved the weakness of partnership as a way to run a large-scale brewery.

Eugene O'Keefe faced another sort of succession crisis that took him all the way to the Supreme Court of Canada in 1889. His brewery was structured as a three-person partnership after he took on two young men to teach them the trade. Their deal provided that if anyone violated certain

agreed terms, the others could ask him to leave the business and give up his share of the brewery's value. One partner, Mead, decided that it would be a good idea to dip into the brewery's accounts "for his own private purposes," including lending money to his friends and relatives while "suppressing all such transactions and not making any proper record or proper entries of the same in the books of the said partnership." Clearly, having sticky fingers was not good for the brewery or for the long-term plans of Eugene O'Keefe. He would carry on his brewing business for another two decades.

As the century was coming to an end and the province continued to expand, Ontario's brewers were providing beer for a population that still remained, in large part, distinctly tied to the British empire, especially in the oldest communities. At the outset of the 1890s, the *New York Times* published a story entitled "A Quaint Canadian City" that noted the following about Kingston:

> *The similarity to the English extends quite noticeably to minor matters, even to eating and drinking. Pipes rather than cigars are smoked in the streets and public places. English relishes and sauces in great abundance are displayed upon the dining tables. Lager beer is wanting almost absolutely. I remember in all my travels, extending through hundreds of miles in Ontario, beginning at this place, to have seen the sign "lager beer" displayed only once. Light wines are rarely called for. Strong ales like Bass's and stouts like Guinness's abound.*

These British ties were not just a matter of taste but also of business opportunity. British brewing investor groups sent representatives to North America to buy and consolidate brewing in the last years of the century. Both Labatt and Carling were attractive enough to receive offers just as they were setting up sales outlets in other provinces, the United States and even overseas. The two London brewers were sufficiently interested to listen on more than one occasion but eventually left offers on the table. They were convinced that their brewing empires were being undervalued.

Instead of selling out, the brewers of Ontario worked together to take on temperance, influence politicians, establish uniform pricing and develop other mutually profitable business practices. The Brewers' and Maltsters' Association of Ontario unsuccessfully took the provincial government to court over the duplication of licensing that Ontario's law created when it was already federally required. The same association agreed to fixed prices in 1897, with eighteen brewers across the province participating in the plan.

By the end of the nineteenth century, the province's brewers had come to enjoy as unregulated a marketplace as they ever would. Over the long reign of Queen Victoria, Ontario had transformed from a controlled society under the Family Compact to a relatively free one with a largely unregulated marketplace for beer and unprecedented prosperity in other aspects of society.

CHAPTER 5

TEMPERANCE, PROHIBITION AND REGULATION

1900–1927

As the new century dawned, the cultural issues around beer and other strong drink in Ontario were well known but still only partially played out. The previous few decades saw the mechanization of brewing within the province, as well as the introduction of its reliance on science over tradition. Beer represented technical progress, yet in the eyes of temperance advocates, it was less and less a drink of temperance than the sibling of hard spirits. Four-fifths of Ontario's people were of British ancestry, but change was coming in that respect as well. Middle-class values of propriety and improvement established in the second half of the 1800s found themselves in a battle with modernity—public health, unionism, commerce and freedom.

There were sixty-one breweries in Ontario at the turn of the twentieth century. There were forty-nine in 1915 and only twenty-three two years later. Carling, Labatt and Sleeman were the biggest three breweries, and only Labatt would survive prohibition operating as an independent business. Per capita beer consumption in Canada at under five gallons of beer per year was well behind the United Kingdom and the United States at more than thirty-four and eighteen gallons, respectively. This, however, represented a doubling of Canadian consumption over the preceding generation. By 1914, the average would be more than seven gallons per capita. Urbanization and temperance joined to bring people closer to beer and breweries and away from spirits.

Ontario itself was expanding. Much of Northern Ontario had remained in the hands of the Hudson Bay Company until 1870, when it relinquished

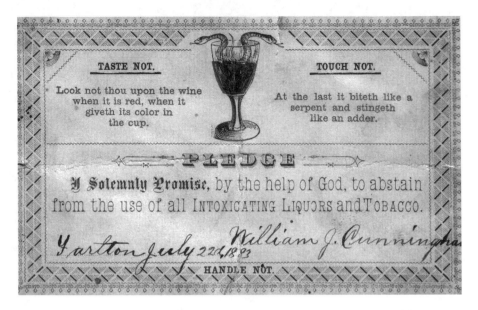

Subsequent to the Canada Temperance Act, pledge cards like this one circulated among those in favour of abstinence. *Courtesy of Milton Historical Society.*

its charter to the British Crown. The small strip above Lake Superior was expanded under the British Parliament's *Canada (Ontario Boundary) Act* of 1889, and the present-day borders of the province were established. In addition to the difficulty of conditions and sheer remoteness, the delay of the area's incorporation into the province stifled settlement.

In 1900, the provincial government commissioned a survey of what was called "New Ontario" to determine what resources might be found there. The report of the survey describes the mission in this way: "The Government of the Province having determined upon a policy of opening up and exploiting the resources of New Ontario, with a view of increasing the industrial wealth and population of the Province as a whole, it became necessary to take stock of the various kinds of natural wealth which existed there."

Ontario was not wild only in its new north. It is worth recalling— especially in this present day, when allegations of neo-prohibitionism are tossed around all too casually—that the temperance movement had an extremely reasonable point. Society still did not have a particularly healthy relationship with alcohol. In his book of childhood recollections of growing up in southwestern Ontario, economist John Kenneth Galbraith wrote that there were two classes of Ontario Scotch immigrants: those who drank and

One fad at the turn of the twentieth century involved attempts to circumvent temperance advocates by marketing beer as a medicinal remedy. Davies's Quinine Ale (above) was not brewed for export to prevent malaria but was marketed as a nerve tonic. The Dominion Brewery and Carling chose to market their stouts to invalids as a dietary supplement to assist with weight gain. *Courtesy of Molson Archives.*

those who didn't. The only purpose for those who drank appeared to be to get stinking drunk. No one, he wrote, "imagined that alcohol had any other purpose." Things were not so different from the early settlement days of the 1820s. Galbraith illustrated this principle in his chapter on the McIntyre House, a tavern in Iona Station near the Lake Erie shore, which saw a night around 1910 when the Campbell boys took on all comers in a hail of fists and whisky: "The next morning a half-dozen clansmen were still stacked like cordwood in the livery stable back of the hotel. None was seriously hurt."

This sort of daily reality was welcome fodder for the anti-drink campaigners. Temperance was not new, but the connection between temperance, a developing understanding of public health and the growth of the Orange Order's authority all culminated in the late-century vision of Ontario: "Protestant, Progressive and Prosperous." It also reflected changes in simpler aspects of life. Less-established workers were moving away from being boarders in hotels and moving into separate apartments. Many hotels sought travellers and a form of respectability that moved them away from alcohol as the sole form of entertainment. Instead of drinking in saloons, Ontarians were going to libraries, playing sports and enjoying other forms of social activity.

The law followed these cultural changes. The second half of the 1800s saw a long, slow retraction of the transfer of licensing of the drinks trade to the local municipal level. The imposition of provincial social standards would culminate in tight wartime federal restrictions enacted in 1916. The restrictions being placed on drinking under the law of Ontario came in gradually and were based on shifts in public opinion, not just the interests and lobbying of a few powerful voices. In 1906, the provincial legislature brought an *Act to Amend the Liquor Licensing Laws* into force, which introduced a number of new restrictions. Stand-alone saloons were being phased out. The number of licenses was being decreased, while license fees were raised. When licenses were distributed to taverns, preference was given to establishments that provided board and lodging as well as entertainment. By 1909, further amendments had made the accommodation aspect mandatory.

The north was catching up. In 1907, a consortium of local business families led to the development of Northern Breweries, starting with the opening of the Sudbury Brewing and Malting Company. Before the beginning of World War I in 1914, the group also bought Soo Falls Brewing in Sault Ste. Marie and then Kakabeka Falls Brewing Company in Fort William near Thunder Bay. Led by J.J. Doran, the breweries retained their local identity

While new breweries were not founded in great numbers in Southern Ontario after the turn of the century, it was different in the north. Without an ale brewing tradition, these breweries made the leap directly toward lager. Silver Foam was the Sudbury Brewing Company's flagship. *Courtesy of Thomas Fisher Rare Book Library.*

This detail from the stationery of the Kakabeka Falls Brewing Company juxtaposes the industrial nature of brewing in 1950s Fort William with the vast wilderness surrounding it. *Courtesy of Thomas Fisher Rare Book Library.*

but were overseen by the Northern ownership group for decades as the new communities grew.

Further advances continued to be made in brewing science. While it might be considered that brewers were not as well organized as they could have been in response to the political and cultural pressures posed by temperance, they did not simply acquiesce in the face of the temperance movement. Their work was modern and socially progressive, as we learn from this description from 1907 of Port Hope Brewing from a commercial directory of the town:

> *The public at large have but a dim conception of the wonderful strides made by brewers of late years, still it is an absolute fact that they have as nearly reached perfection as is possible for human skill to do. Port Hope possesses its full share of the many good things of life, and not the least important is The Port Hope Brewing Co., Ltd. This brewery is noted for producing ales and porters that are seldom equalled and never excelled. Sparkling ale is today a popular beverage, but not as a beverage alone have they attained a wonderful popularity. They have become an absolute necessity in nearly every household, no matter what station in life its people may occupy.*

This proud—even ripe—Edwardian prose about the benefits a modern brewery brought to an Ontario community in the new century stands in contrast to the prohibitionists' message. The beer has remarkable flavour and is wholesome, with a purity of ingredients. The brewery is fully equipped with the latest machinery and appliances known to the trade and has spacious cellars that afford ample storage for the product. The stock is allowed to mature for months before marketing. Management exercises close and critical supervision over all departments of the business. Fat chance of anyone being stacked like cordwood after sampling the delights of Port Hope's cellars.

These scientific changes were an important trend in the first decade of the 1900s and with some justification beyond temperance. In a paper presented to the *Journal of Institute of Brewing* in 1907, Englishman Thomas Hyde described a trip to Toronto, Ottawa and Montreal during which he noted that the brewers were brewing in a way that seemed old-fashioned, using nothing but malt and employing a method "very similar to what obtained in England prior to Mr. Gladstone's Beer Duty Act of 1880." He described the beer of one brewery in this way:

> *All the ale at this brewery was of stock ale gravity, and after fermentation it was stored for two or three months in casks as well as in large storage vats.*

The rapid shift in ownership around the turn of the century meant that the name of a brewery could very quickly change. This happened with Port Hope's Ambrose and Winslow, which became the Port Hope Brewing and Malting Company, despite Ambrose's continued involvement. *Courtesy of Molson Archives, Thomas Fisher Rare Book Library.*

To both a liberal supply of dry hops was added. Although they had a large ice plant in duplicate, they did not believe in cooling their storage cellars...I tasted the beer, both on draught and in bottle. It was not at all nice and had a pronounced old, harsh flavour, and devoid of character in every way.

Hyde shared a conversation with one unnamed brewery owner who admitted to him that the market was changing and that they were not quite sure that their beer was meeting with the demand that they wanted. The solution was the Wittemann Process, which was being used in a New York brewery and promised time savings; an end to cellaring; and lighter, more modern beer. Hyde was no more impressed with that plan than the poor state of the beer.

Moving ahead with the times, breweries were seeking ways to present themselves as a positive part of community life. George Sleeman of the Silver Creek Brewery of Guelph had been active in baseball and other sports for decades before 1900. In the first decade of the new century, sports like hockey and baseball were only beginning to be organized into leagues of paid professionals, meaning that amateur recreational sports were well organized. In 1909, Labatt sponsored a trophy for the Western Ontario Bowling Association. In 1915, the London Thistles curling rink won another trophy, also supplied by Labatt.

Brewers were also facing problems caused by the generational changes in the families who controlled them. The shift from the second to the third generation was fraught with difficulty for breweries that had survived the period of early industrial brewing and expanded through the heady late Victorian period. By 1910, Ontario's biggest brewers were still family businesses that had created great wealth and the expectation of dynasty. Before the end of the First World War, all would face a crisis.

Sir John Carling had survived the losses of both his business partner and brother, William, and his brewery in 1879. He had triumphed over disaster and rebuilt, incorporating the Carling Brewing and Malting Company, which he directed until his passing in 1911. The brewery's fortunes changed when control passed to Sir John's son, Thomas. Thomas had played a major role in business operations, but unable to keep going under prohibition, he was forced to downsize and then shut the doors. He put the family's last twenty-five brewery employees out of work in 1920.

Guelph's Silver Creek Brewery suffered a similar fate. In 1896, it was one of the biggest breweries in Canada, with five brewing plants within the province. The first trouble came in 1902, when bankers took over the

brewery after the founder's son, George Sleeman, had unwisely invested in a street railway scheme for his small city. The family recovered control in 1906, with management of operations being placed in the hands of the third generation, Henry O. Sleeman. Transferring production over to new equipment at their Springbank brewery, Henry, along with his siblings, bootlegged alcohol through the years of prohibition in Ontario and the United States. They finally ended the family's brewing business with charges and license suspensions for smuggling and tax evasion.

O'Keefe's path was more caught up with peculiar circumstances. After the partnership arrangements that intended to allow Eugene O'Keefe to move out of the brewing business collapsed and ended up in the Supreme Court of Canada, O'Keefe incorporated in 1891 as O'Keefe Brewery Company of Toronto Ltd. The brewery expanded in 1911 to a capacity of 500,000 barrels, but in that same year, O'Keefe's son and heir died and, with him, the family's amended succession plans.

O'Keefe sold his shares to his former partner's son, Wider Hawker, and then passed away himself in 1913. Shares in the firm ended up in a holding company, which was in part controlled by an eccentric lawyer, Charles V. Millar, whose will included an interesting clause. A large portion of the wealth that O'Keefe's brewery had generated went as prize money for the winners of Toronto's famous Stork Derby, which ran during the ten years after Millar's death and rewarded the woman who had the most children in that time.

Of all the well-known names in Ontario's brewing industry, events at Labatt were happiest. The founder's son, John, governed the firm until 1915, when he passed away at seventy-six years of age. Of all the Ontario breweries whose names have continued, Labatt was the best prepared for the contingencies posed by both the coming of prohibition and legacy planning. In 1911, John Labatt created a trust in his will leaving the ownership of the brewery to his nine children collectively, with day-to-day management passing to his two sons, John S. and Hugh F. Labatt. Major decisions required the consent of their seven sisters; the consensus provided an ironclad safeguard.

While Carling declined immediately upon the declaration of prohibition, and O'Keefe lost its way with the loss of its heir apparent, Labatt successfully transferred the wealth, brewing skills and business acumen to the third generation and beyond. And unlike Sleeman, it sought to maintain and expand brewing production within the bounds of the law. During Ontario's years of temperance, production and export were not banned. Labatt moved beer into the United States on boats it ran across Lake Erie and

into Michigan. Casks were sometimes slipped onto trains passing through Ontario travelling on to the United States.

Labatt took some pains to remain relevant to a changing society. It took steps to support its workers. In 1907, bottles of its beer began to carry the words "union made," as it joined the International Union of Brewery Workers. It was a smart move, as sales rose through the buying power of organized labour. In 1919, its horse carts for local delivery were replaced with motor trucks, each capable of carrying ninety-six casks. In 1920, the year when fellow London brewer Carling closed up, Labatt chose to give its employees annual paid vacation benefits.

Even though prohibition is said to have lasted in Ontario from 1916 to 1927, the province experienced a number of forms of temperance regulations. Laws had been in place for decades allowing local communities to prohibit alcohol within their boundaries. These laws were the result of both temperance lobbying and genuine public disinterest in alcohol. The march toward prohibition, however, was not smooth. In 1906, the law was amended to raise the vote required in Ontario to pass a local option to 60 percent.

In the 1914 election, the Liberal Party campaigned for prohibition. The provincial Conservatives won by a wide majority based on the local option, but their leader died within months and was replaced by Premier Hearst, a temperance supporter. In 1916, Hearst's Conservatives tightened the law. Introduced as a temporary wartime measure, it still did not fully prohibit the consumption of alcohol. It made the possession of liquor and beer outside the home illegal. A "cellar supply" for personal consumption was permitted, but selling strong drink became illegal. In his speech to the legislature on the second reading of the law, Hearst relied on the duty to implement wartime efficiencies and also cited medical and criminal experts who associated alcohol and saloons with most of the ills attached to society. For the moment, temperance was in control.

Still, the question was far from settled. In 1918, organized labour rallied in Toronto for the introduction of 2.5 percent beer. Five thousand workers and war veterans were met by Premier Hearst, who rejected their demands. In 1919, a lobby group called the Citizen's Liberty League ran ads in newspapers stating that the Ontario Temperance Act (OTA) had been brought in as a war measure and without a referendum, in violation of personal liberty. While opposed to the "return of the open bar," they advocated for the law's repeal and replacement with a more moderate scheme that allowed some alcohol. They also warned that once prohibition was brought in for drink, the cigar and pipe were next.

The fact was that people were simply not complying with the law. The reality was a different matter for the brewers of Ontario. Provincial law did not have the authority to regulate the brewing industry itself, and the national government never introduced a ban on brewing for the export trade. As a result, beer could be imported into Ontario. It became so common that in 1919 the OTA had to be amended to bar the publication and distribution of price lists and order forms for beer and other sorts of alcohol. Humourist Stephen Leacock captured the absurdity of the mix of morality and law in his narrative essay "Dry Toronto":

> "[W]ill you please tell me what is the meaning of this other crowd of drays coming in the opposite direction? Surely those are beer barrels, are they not?" "In a sense they are," admitted Mr. Narrowpath. "That is, they are import beer. It comes in from some other province. It was, I imagine, made in this city (our breweries, sir, are second to none), but the sin of selling it"—here Mr. Narrowpath raised his hat from his head and stood for a moment in a reverential attitude —"rests on the heads of others."

Many Ontarians refused to be told that they could not meet together over a beer as they always had. In a 1920 court case, someone charged of keeping alcohol for sale had raised the defense that the place of drinking was his residence. There was ample evidence that the accused had strong beer on his premises, but he claimed that it was for his own private use. Unfortunately for him, there was plenty of other evidence: "[O]n the occasion when the police entered, a man who was not the accused was having a meal at which he was drinking beer; that there were a large number of empty gin-bottles and beer-bottles in the place; drunken men had been seen going into and coming out of the house on several different occasions."

The implications were quite serious for people found running this sort of illegal beer hall: a minimum $200 fine could escalate to three months in jail and even hard labour if the case demanded.

On April 18, 1921, a plebiscite was held on the question of the importation of alcohol into Ontario. The question asked was: "Shall the importation and the bringing of intoxicating liquors into the province be forbidden?" More than 60 percent of voters said yes. The split was decidedly along the rural/urban divide, with cities like Ottawa, Hamilton and Windsor voting to allow the flow of imports to continue. The city folk lost. The province, newspapers declared, was now actually bone dry.

The new law was as ineffective at stopping the flow of beer as the old law had been. One factor was that there was a massive amount of brewing going on within the province that wasn't intended for export. A certain level of home-brewing still occurred under special permit. Toronto brewers lobbied the government in 1922 to limit home-brewing permits, claiming that jobs were being lost. As a result, beer under 2.5 proof was soon exempted from prohibition, and combined with the home permit, it was just possible that more than a few Ontarians were supplying themselves with the "real stuff" that the law supposedly banned. While it was impossible to enforce laws preventing home-brewing, the government kept a watchful eye on commercial brewers. In January of the same year, the Springbank Brewery of Guelph pleaded guilty to charges of selling intoxicating liquor and was fined $1,500.

The courts did not line up in lockstep with the government of the day to enforce prohibition. The Appeal Division of the Supreme Court of Ontario in 1923 threw out the ban on transporting beer by highway, finding that the Walkerville Brewery of Windsor was entitled to drive truckloads of beer for export to wharves under federal law. Two years later, the same high court overturned two lower courts to let O'Keefe Beverages Ltd. off the hook for a shipment of legal 2.5 proof beer sent by railway that contained cases of illegal strong beer. What makes the decision unbelievable is that the brewery just happened to send fifty cases instead of twenty cases. It sent them to the near northern community of Gravenhurst in the name of the grandmother of the man who wanted them. The appeal court judge determined that a delivery with no paperwork was not a crime. Those who were accused went free.

Opposition politicians knew what was really going on. Before becoming premier in 1923 after defeating the postwar United Farmers of Ontario/ Labour coalition government, Howard Ferguson stated that the current law was training Ontarians not to respect it but to defy it. Despite the law, there was good money to be made in beer; acquisitions and consolidations continued. Carling had been reopened in 1922 by J. Innes Carling, a grandson of John, who restructured under the name Carling Export Brewing and Malting Company Ltd. It was sold off in 1924 to the shady Windsor firm of Low, Burns and Leon. It was involved in the rumrunning trade to the United States and refocused the facility to light lager production for American speakeasies and bootleggers.

The new operators of Carling Export found themselves in trouble in no time. They used stolen U.S. custom seals and disguised beer as other goods when shipping by rail. They were charged with tax evasion, and

the case went all the way to the Supreme Court of Canada. Among other things, the court found that that 17 percent of Carling's beer had not, in fact, been exported between 1924 and 1927 but was instead dispersed in cash sales throughout Ontario. The appeal court also, whether it knew it or not, preserved for posterity an important shift in the lightening of Ontario beer:

> *I do not think we can accept the suggestion that there was no market for lager beer in Ontario. The learned trial judge dwells upon the fact that rice beer is peculiarly an American taste, and infers that it is not sold in Ontario. The evidence in support of this does not proceed from disinterested sources and I wonder whether the boundary line so sharply affects the taste in illicit liquor. In truth, it is stated by Low that it was not until sometime in 1926 that the respondents began the manufacture of rice beer, and we are not told at what date, if ever, in their brewery, rice beer wholly superseded malt beer.*

Even though U.S. Prohibition lasted until 1933, the new Carling business model did not last long, even if Ontario's beer was changed forever. In a few years, the brewery would have its good business name resurrected under E.P. Taylor's control. Carling Black Label, the brewery's future flagship, earned its loyal following through 1920s prohibition smuggling. Along with such corporate restructuring, eleven of Ontario's brewers also built on their habits of cooperation and consortium-building with the creation of the Bermuda Export Company to better manage the group's price fixing and production quotas for the lucrative trade into the dry states to the south.

Aside from their love of beer, one of the main reasons for Ontarians' loss of interest in the experiments with prohibition was how it undermined public trust or even interest in the rule of law. As Heron shows, the bootleggers prospered while judges ruled against many prosecutions, and the police were often corrupt. Many Ontario brewers in addition to Carling, like Kuntz and Cosgrave, were actually illicitly brewing for the local beer market by a cash-and-carry system and would deliver to hotels.

The corruption related to the brewing and distilling industry reached beyond the general population and up into the highest levels of government. The final report of a parliamentary committee in 1926 noted that federal cabinet member Jacques Bureau, while serving as minister of customs, had received gifts of liquor from Montreal customs officials. A Royal Commission reported in 1928 that the O'Keefe brewery had simply hidden its records of actual brewing activities or had just burned them.

Labatt sold so much beer south of the border during prohibition that its workforce grew from 68 to 104 between 1922 and 1925. In the spring of 1927, the brewery was implicated in offering kickbacks to customs officers in testimony before the Federal Royal Commission on Customs and Excise as it took evidence in hearings across Canada. When a shipping clerk named Aikens admitted under oath that he sold strong ale in London and the vicinity, he explained that he sold only to people whom he knew; an official congratulated him on his host of friends. Labatt did, however, insist to the commission that it had stopped shipping by camouflaged rail car in 1924 and, unlike most of its competition, had accounted for all taxes due.

Support for temperance was weakening based on public awareness of the failure of the law and the corruption it brought. In October 1924, when another plebiscite on temperance was held, the vote against repeal had fallen to only 51.5 percent. Major population centres like Toronto, Ottawa, Hamilton and Windsor all voted against keeping the law. In response, Premier Ferguson raised the strength of permitted light beer to 4.4 proof from 2.5 and also redistributed the seats in the legislature to remove wet seats and add dry ones. Reaction to the new beer was not rabid, as noted in the June 4, 1925 *Stouffville Tribune*:

> *To the imbibers who thought that they were going to get some kick out of the potation, the ordination was as disappointing as a cancelled marriage license to an old maid. Many of them claimed, in fact, that the new beverage bore such a family likeness to the old 2 percent that it might be its twin brother. Unlike the stuff that made Milwaukee famous, there was no blinds staggers accumulated from the new suds. Temperance people who thought the wolf was here in sheep's clothing will have to wait a while.*

Not surprisingly, Ferguson won reelection in December 1926 on the platform of repeal of the temperance law and replacement with a system of government-controlled liquor sales. In an article titled "What the Wet Victory Means," the immediate aftereffects were described in this way:

> *As already announced by the Premier, provision will be made for the sale, in sealed packages of liquor wines and beer, obtainable from government shops only, in cities and towns, and such municipalities as may desire to apply for the provision. There will be no beer parlours, according to the Premiers' latest pronouncement: no beer will be sold in public places by the glass.*

In 1927, Ontario's experiment with prohibition ended with the repeal of the Ontario Temperance Act and its replacement with the Liquor Control Act. Along with the new law, the Liquor Control Board was founded. The people of the province were once again drinking full-strength beer in their homes, albeit after purchasing their drink at a government-controlled store and transporting it in a sealed package. The new laws created new cases for courts—such as the pressing question of whether the owner of a hotel could have liquor in his own rooms. Municipalities were voting in large number to apply to have one of the new government stores located within their borders. The experiment based on moral constraint and control had been swapped out for a new experiment with government regulation and control.

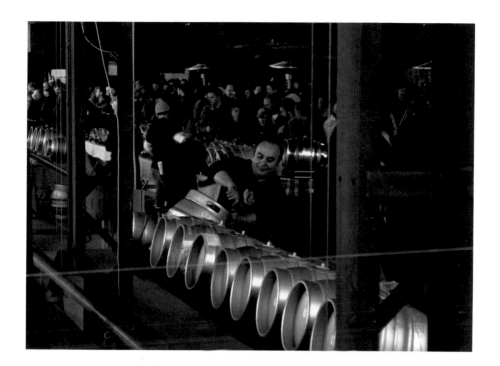

Above: One of the holdovers from Ontario's English brewing heritage is the popularity of cask-conditioned ales. Cask Days, objectively Canada's best beer festival, serves beer only in this format. *Courtesy of Mikael Christensen, SJWJR3.*

Right: One fad at the turn of the twentieth century involved attempts to circumvent temperance advocates by marketing beer as a medicinal remedy. Copland's Tonic Stout featured Dr. Jackson's Roman Meal, a barley-based nutritional supplement named after the all-barley diets of gladiatorial combatants, the hordearii. *Courtesy of the Molson Archives.*

Pictured here are two of the original design drawings for Labatt's iconic Streamliner delivery trucks. The futuristic designs created an indelible impression on motorists on Ontario's early highway system. *Courtesy of the University of Western Ontario.*

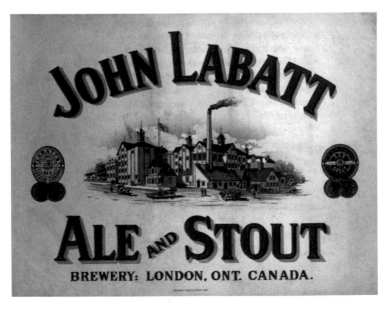

This poster details the evolution of Labatt's branding. The family name is included, as are the labels featuring their awards. *Courtesy of the University of Western Ontario.*

A difficulty of using agencies in other cities to sell beer was that one's product might end up being imitated by the local competition. In the case of this Labatt's label, a local Montreal vendor created a version that might pass scrutiny from a few feet out. *Courtesy of the Molson Archives.*

In many ways, the simplicity of the Cosgrave badge in the late nineteenth century was more effective than its subsequent branding. *Courtesy of the Molson Archives.*

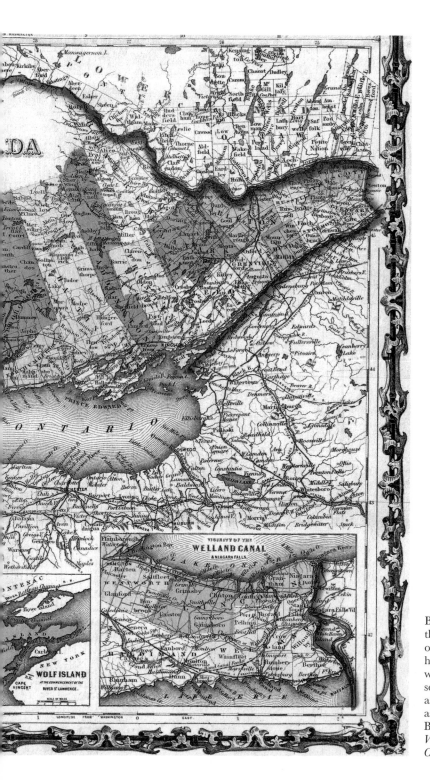

By 1862, the map of Ontario had filled in with regular settlements as far north as Georgian Bay. *Courtesy Wikimedia Commons.*

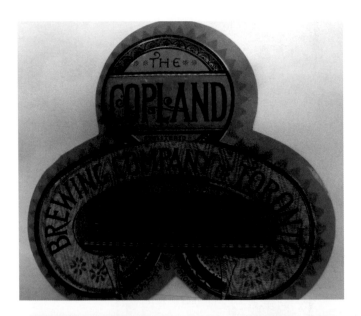

Top: At another
point in the late
nineteenth century,
Copland chose to
use the shamrock
as the entirety of its
label. *Courtesy of the
Molson Archives.*

Left: Charles
MacLean is one
of the formative
influences in
modern brewing
in Ontario. It is
unlikely that cask
ales would feature as
prominently without
his dedication.
*Courtesy of Ontario
Craft Brewers.*

Left: It has not always been as complex as it is today. Bellwood's Blitzen Imperial Saison with Lemon and Plum would have made Cosgrave scratch his head. *Courtesy of Katy Watts.*

Below: The Barley Days of the late Victorian period have been the inspiration for a local brewery in Picton, Ontario. *Courtesy of Katy Watts.*

Left: The idea of seasonal brewing has been with us for some time, as this circa 1930 label from the Cosgrave Brewery demonstrates. *Courtesy of the Molson Archives.*

Below: In Eastern Ontario, stock ale rather than lager survived after prohibition. The label is an early form of the patriotic appeal that Molson would use subsequently. *Courtesy of Jim Maitland, Molson Archives.*

Above, left: This late Victorian bottle from the Eaton Brothers brewery in Owen Sound is a good example of the phenomenon of a blended half-and-half beer. Eaton Brothers would later switch production to an IPA. The motto "shamed be he who thinks evil of it" served as an early critical deterrent. *Courtesy of Jim Maitland, Thomas Fisher Rare Book Library.*

Above, right: The Calcutt Brewery of Peterborough provides an excellent illustration of the changing times. The brewery retains its crest and motto despite the change from Extra Stout Porter in the 1890s to Trent Valley Lager after prohibition. *Courtesy of the Molson Archives, Jim Maitland.*

Left: In contrast to Eaton Brothers, the flagship of Owen Sound's Kilannan Brewery is an altbier, featuring symbolism that neatly combines German and Scotch-Irish heritage. *Courtesy of the Kilannan Brewery.*

"MY DAUGHTER PUT IT UP WHEN SHE BECAME ENGAGED. THE NEW LABATT IPA LABEL IS HER WAY OF SAYING SHE'S GOT HERSELF A _MAN_"

John Labatt II brought the secret of IPA back to London in 1864. Winner of more awards than any other ale, it is famous as a MAN'S drink! Next time ask for IPA. If you enjoy an ale with that old-time flavour you'll like this man's drink too!

The swing is _definitely_ to Labatts!

By the 1950s, Labatt was selling its IPA through the dual virtues of tradition and manliness. In subsequent decades, the IPA would swing right out of the product line. *Courtesy of the University of Western Ontario.*

The Granite Brewery was one of the first brewpubs in the province of Ontario to offer two-litre growlers for take-home consumption. The idea has since caught on with small breweries across the province and circumvents the Beer Store as a distribution channel. *Courtesy of Ontario Craft Brewers, Walkerville Brewery.*

Branding is one of the strengths of the craft brewery movement in Ontario, and the time and effort put into the labels on Beau's packaging is a highlight of the trend toward inventiveness. The authors are particularly fond of the Vassar and Staghorn labels. *Courtesy of Beau's All Natural Brewing Company.*

Pictured here are two labels from the Victoria Brewery in Ottawa from the decade before fire razed the neighbourhood. *Courtesy of the Molson Archives.*

Although brewed more than a century apart, these beers have some commonality. Barrel aging would have been common in the Victorian period, although it did not have the same marketing cachet. *Courtesy of the Molson Archives and Doublenaut.*

Sleeman's resurrected brand reclaimed its beaver trademark and incorporated it into the bottle design. *Courtesy of the Molson Archives.*

Right: At one point, O'Keefe branded all of its beers with the term "Imperial," which in this case probably indicated a bock-strength lager. *Courtesy of the Molson Archives.*

Below: While craft breweries have thrived since 2008, they cannot compete directly with the volume of large brewers like Molson, whose new fermenters required a convoy for installation. *Courtesy of Molson.*

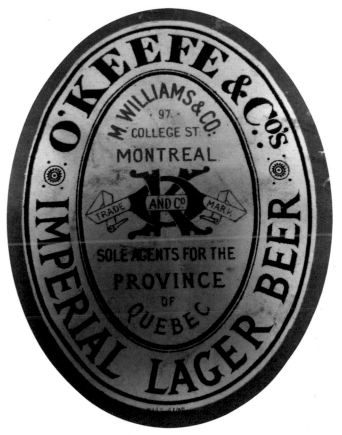

Steve Beauchesne and John Hay of the increasingly influential Ontario Craft Brewers Association observe the proceedings at the first annual Session Beer Festival in Toronto. *Courtesy of the author.*

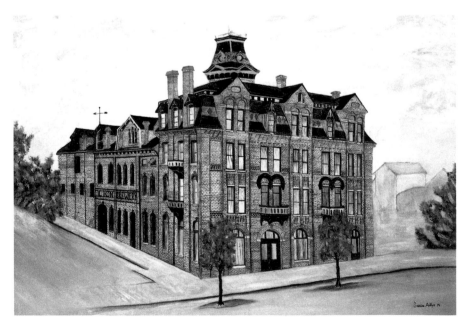

The Huether Hotel and Lion Brewery were given a rebirth by the Adlys family of Waterloo, who have highlighted the heritage of the property. *Courtesy of Sonia Adlys.*

CHAPTER 6

CONTROL, CONSOLIDATION AND THE RISE OF NATIONAL BREWING

1927–1980

The new system of control was far from successful—possibly less successful than Ontario's version of prohibition had been. When the new law came in supposedly allowing for full-strength beer, 90 percent of Labatt's beer already met the higher standard. There were no legal saloons or taverns as there had been before prohibition. The law-abiding hoteliers who had been authorized to serve the new light beer still had to contend with "blind pigs," or illegal taverns. Some other hotels were licensed but had little regard for the limits of what was allowed. Loopholes in the law deeming a hotel room a private residence opened up a new way to throw a party. Ontarians and eager U.S. tourists were able to access full-strength beers and other drinks even under the attempt at tight control that existed from 1927 to 1934.

One man defined the brewing industry in Ontario in the middle third of the twentieth century: E.P. Taylor. After the twin blows of prohibition and economic depression, Taylor saw an opportunity to replicate in Ontario the mergers that had taken place in Quebec led by Dawe's National Brewing a decade earlier. In 1928, there were just three breweries in Quebec. Before World War I, there had been more than five times that many. Before the Great Depression struck in 1929, E.P. Taylor had already worked out a plan to acquire and merge a large number of regional and local brewers with the goal of controlling half the brewing capacity in the province. Virtually all Ontario's firms but Labatt and the breweries controlled by the Doran family in the north were his targets. Taylor's intentions were so fixed that when an

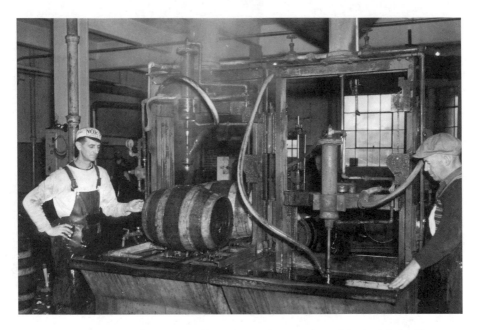

Labatt's keg washing line, circa 1930. Note that the construction of the barrels is still wooden. *Courtesy of University of Western Ontario.*

agent of English investors approached him in the early 1930s about buying into the Doran breweries, Taylor redirected the funds into the creation of what became known as the Brewing Corporation of Ontario Ltd.

One of the most interesting aspects of E.P. Taylor's plan and his corporation is that he executed it after the stock market crash and accomplished it without having the required funds. His total assets included his intelligence, his business connections and a grandmother, who owned one-third of the shares of Ottawa's Brading Brewery. That was all the twenty-seven-year-old Taylor needed. He had been working in securities for a number of years, financing corporate deals, and was invited to join the brewery's board. He intended to bring about the closure of breweries that accounted for 20 percent of beer sales across Ontario to create a competitor large enough to take on Labatt. He was the right man for the job. E.P. Taylor's description in a 1932 auditors' letter to his firm's bankers is telling: "He is a very young man but quite capable, although probably not thoroughly experienced in the manufacture of beer. However we think he has good organizing ability and is capable with lots of self confidence in the eventual success of this organization."

There was good reason for such a view of Taylor. At the end of 1931, he had already taken control of not only Brading but also British American, Carling, Kuntz, Taylor and Bate, Dominion and Empire, as well as the properties that had made up the Hamilton Brewing Association. Even though Taylor's profitable breweries had made less than $100,000 that year while his money-losing plants lost almost $600,000, his redefinition of modern production processes and efficient corporate structure was working as expected.

By 1931, Taylor already controlled 27.5 percent of all Ontario beer sales, and his biggest acquisition was yet to come. In 1934, Taylor knew that the government was planning to amend the law to allow beer to be sold by the glass in public places. The further relaxation of existing law was due in part to all of the party lobbying by an organization called the Moderation League of Ontario, which he was partly responsible for funding.

The O'Keefe Brewery Company was the grand old name in Toronto brewing when Taylor made his approach. Taylor recounted for a 1980s biography how the deal required more than $2,000,000 to pay out various trusts and estates that controlled O'Keefe. Neither his current bankers nor profits from the brewery could be expected to match half that sum. Once again, British investors answered the call—literally, as it turned out the deal was struck during one telephone conversation with a Scottish stockbroker. With that one transaction, Taylor added another 10 percent to his control of the Ontario market.

What was the beer like? In a 1933 photo of Taylor toasting the acquisition of O'Keefe, the beer glasses being clinked are filled with a decidedly darker sort of opaque beer, with a rich, white head. Flagship beers were still years away from being light.

The brewing marketplace that E.P. Taylor was creating was optimistic and progressive even as it was overlaid with the social controls imposed by the Liquor Control Act. Since first enacted in 1927, the system had been amended to allow public access in hotel settings, but it was still, as argued by academics Thompson and Genosko, based on the principle that "[s]urveillance in the form of governmental oversight was the key that enabled the compromise between the moral regulation sought by the temperance movement and the freedom sought by those with a desire to consume liquor legally in the province."

While this view of the new order as oppressive is arguable based on the laws as implemented by the provincial government, the historian Mallack has observed that the Liquor Control Board (LCBO) and its staff were unable

to truly bring about the full application of these theoretical powers. The limits of surveillance techniques and communication methods constrained the ability of the central administration to enforce its broad authority.

The role of women in this era of hotel-based beverage rooms was also a great cause of concern. The reopening of public drinking places may have led to perceived moral dangers such as gambling and prostitution, but realistically the problems were less tawdry and more practical. In some cases, concessions had to be made to prevent the harassment of the modern women who wished to seek out new entertainments outside of the home. Soon after the changes in 1927, as Mallack notes, the proprietors of the Hotel Grimsby asked for the right to "prepare a Ladies Beverage room, as a great number of ladies do not want to go in the same room as the men." Before further amendments in 1934 addressed the concern, efforts were made to meet this demand by individual hotel operators. In one case, this required the use of a dining room as a restricted location for women. The LCBO was sympathetic but did not approve of the circumventing of the law required, with the inspector reporting it as "the subterfuge of the sandwich."

Restricted access to the beverage room applied to servers as well as female customers. Unlike their male equivalents, female servers were subject to official inquiries about whether they were sources of immorality. Social clubs serving women or a mixed membership were, at times, ordered to stop serving beer except to men. The beer-drinking woman who chose to avoid the public space and stay at home when drinking also faced public disapproval when purchasing alcohol and risked being subject to commentary in the press.

Throughout this time of social transition, in addition to working with the provincial government in the implementation of the Liquor Control Act, brewers were quite able to work with one another when their interests aligned. In 1933, E.P. Taylor corresponded with his Quebec competitors National and Molson, sharing information related to retail price-cutting by their own agents. The next year, Carling received plans about the use of cardboard cartons to replace wooden crates to achieve freight charge savings and provide greater convenience "for tourists, for people going fishing, and so forth."

Under Canada's division of powers between the federal and provincial levels, the government of Ontario regulated how beer was retailed. Changes made in 1934 continued to reflect the surveillance principle even as settings for alcohol consumption and modes of drinking expanded. The law now defined the word *establishment* to include club, hotel, inn, public house, tavern, military mess, restaurant, railway car or steamship as having premises.

Among the many classes of license created, licenses were now also available for establishments that served beer to men only, to men and women together or to women only. A few remaining "ladies and escorts" signs from this era can still be seen in rural Ontario, such as at the Douglas Tavern in Renfrew County. Licenses were also available for light beer only or beers of any strength, as well as other forms of alcohol. By creating separate zones for different economic groups, different genders and different beers, the bad old days of the wild taverns warned of by the temperance movement could be avoided, as each group selected its establishment of choice.

In addition to efforts to modernize the drinking of beer by making public drinking safer and more acceptable, efforts were undertaken to modernize beer stylistically. As the key to the Liquor Control scheme, beer was intended to be lighter and more convivial. It was a way to the future, and the futuristic style of beer in Ontario was no better expressed than in the Streamliner, the sleek tractor and trailer that Labatt chose as a means to get its beer off the rails and onto the highways. The 1920s and 1930s saw the development of the Kings Highway system, which allowed for rapid transportation deeper into Ontario beyond the reach of trains. The flowing lines of the Streamliner served as a bright-red bullhorn proclaiming Labatt's beer throughout the province's towns and cities during a time when beer advertising was barred by law. The Streamliner delivery truck was designed by auto designer Count Alexis de Sakhnoffsky, a Russian aristocrat who escaped the Soviet revolution and described himself as an engineering stylist. His designs for Labatt evolved over four generations from 1935 to 1947.

Labatt also responded to the new opportunities in more pedestrian ways. It created a special services department in 1935 to assist hotels with the installation and maintenance of the new equipment required to serve draft beer. Labatt's message to the public reflected a mix of new technologies and a shift in community values. In contrast to E.P. Taylor's mergers and acquisitions, Labatt had lasted under the same ownership structure through the years of prohibition and the Great Depression. Its intentions were clear and defined by the new choice of delivery methods. Beer was now modern, progressive and for everyone.

Ontario's brewing production had doubled between 1933 and 1939. In September of that year, E.P. Taylor spoke at a meeting of the Brewers Warehousing Company and left us with a picture of the values and economics of Ontario's brewing industry. As war had just been declared, the tone was certainly patriotic, but it was also entrepreneurial. Taylor argued that the lowest price possible for beer should be established to decrease "wasteful

selling expenses" while increasing sales, volume and taxes for the war effort. Profits would also rise. While not the start of the concept of commodity beer, this statement certainly places it at the centre of Ontario's way forward.

In 1927, at the close of the province's dalliance with prohibition, Brewers Warehousing Company Ltd. was founded as a brewers' distribution collective. The provincial government retained control of the sale of wine and spirits through the LCBO, but beer, with its lower alcohol content, could be distributed by hundreds of mom and pop stores. Initially, the brewers were involved only in wholesale operations, jointly warehousing and distributing their product to stores operated by private contractors. In 1940, the brewers bought out the retailers and took over the stores, changing the name to Brewers Retail Inc. The stores were later renamed the Beer Store.

The war also encouraged E.P. Taylor to renew his correspondence with the president of Molson that dated back to at least 1932. In 1942, Taylor suggested quite an arrangement:

> *Don't you think for the duration of the war we should arrange to divide the business in the two provinces in a fixed proportion and cut out most of the waste? I fully realize that your Company is not as extravagant in Ontario as some of the rest of us and you are certainly in an enviable position in that regard. At the same time I think that if you gave leadership to a proposal for pooling the business until after the war, everyone would feel inclined to work something out.*

Labatt also took its place in the war effort. In 1943, it was reported that not only were patriotic efforts such as war bond drives undertaken, but trucked shipments were also moved back to railroads, while a trade school for army motor mechanics was operated out of the brewery's garage. The brewery ran a series of weekly panel cartoons on good citizenship standards under the title *Isn't It the Truth by Ti-Jos.* Topics included household prudence, supporting price controls, rumour-mongering as treason and the evils of the black market. In doing so, the brewery clearly was associating itself with the patriotic values of the middle class.

Wartime on the homefront changed social attitudes to public beer drinking. Higher employment and earning levels increased disposable income. Hotels serving beer to men and women no longer carried a dangerous air so much as a patriotic one. Increased accommodation for beer sales also served the financial interests of business and governments during the war. Beer sales more than doubled during the war years, and the federal excise tax on each

gallon of beer brewed increased by 36 percent. Further, a difference in the relative level of taxation in Ontario caused a significant shift in drinking patterns to beer from spirits.

Two forces combined to impose on the expansion of beer sales in the second half of the war: a renewed temperance movement and resource scarcity. Under direction of Prime Minister Mackenzie King, temperance as a countervailing patriotic theme was promoted, causing a public clash between King and E.P. Taylor. At the same time, the national Wartime Prices and Trade Board imposed a quota system to distribute beer as it would other commodities that created shortages. In March 1943, when Kingston received an increased allocation to reflect troops being stationed there, other communities received a reduction in their share. Overall, a 90 percent reduction was imposed on beer distribution, beverage room hours were restricted and, as a result, the beer casks were dry when the night shift at the factory ended. In protest, some took to wearing "No Beer—No Bonds" buttons.

After victory was won, the topic in one of the last editions of Labatt's *Isn't It the Truth* series was the return of the young soldier to the family home. When Mother tells him that there's no rush to get a job, he replies, "I've been doing a man's job for four years. Now I am all ready to get going here at home." Labatt was associating itself with the sort of moral productivity that continued into the postwar boom. Life in Ontario had been fought for and won, but it would still have to be worked for. The brewery continued that theme in 1946 in a series of ads asking Ontarians to do all they could to make tourists from the United States feel welcome—hints from "a well-known Ontario hotelman," including that, in business dealings, Canada's reputation for courtesy and fairness "depends on you!"

The new economic opportunities led to changes in Ontario's brewing industry addressing the need for consolidation and succession in light of financial success. In 1945, Canadian Breweries fell under Argus, E.P. Taylor's larger holding company. After spending the first years of the war at the top levels of the British effort to maximize production, Taylor had returned home exhausted in 1942 to focus on Canada's war efforts as a member of National boards. He would also prepare for the future of his brewing empire.

Well before the war had ended, he had given instructions to have modernization and expansion plans in place for facilities to be ready for brewing in Waterloo, Toronto and Ottawa as soon as the fighting ended. He moved to secure assets in the malting industry, as well as an American

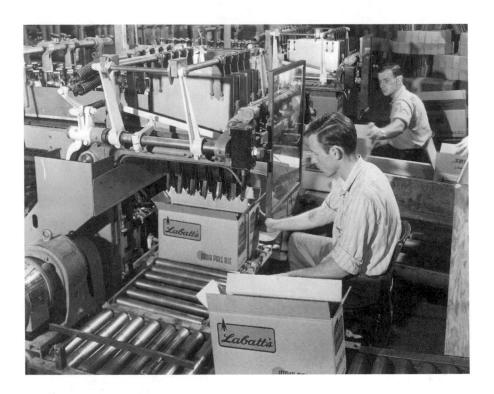

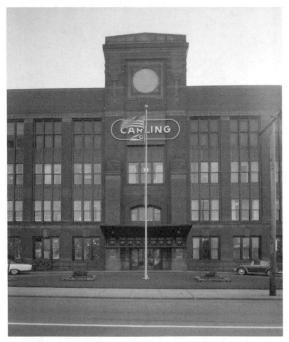

Above: The technological advancements of the twentieth century created the opportunity to streamline production facilities not just at Labatt but also at breweries across the world. *Courtesy of University of Western Ontario.*

Left: Carling's ambitions throughout E.P. Taylor's expansion included foreign properties, including this converted automotive company from Cleveland, Ohio. *Courtesy of Library of Congress.*

brewery, to reduce his exposure to Canadian government policies. He believed that there would be a postwar boom in the market for beer.

In December 1945, something happened in Ontario that had not occurred for more than thirty years: a new brewery was constructed. The Peller Brewing Company in Hamilton was founded by Andrew Peller. He was a former brewer with the Cosgrave brewery in Toronto, and he was backed by Hamilton businessmen. Although it operated independently for only eight years, the brewery he built would remain important and shows up a few more times in the province's brewing history. Peller went on to open a daily newspaper in Hamilton that soon failed. He then went on to create one of Canada's first large-scale wineries, the makers of Baby Duck and Peller Estates brands. In brewing, he is best remembered for getting around the restriction on advertising by opening an ice company and plastering the brewery's trucks with the Peller logo and the message, "Don't Forget The Peller's Ice."

The new Liquor Control laws of 1944 and 1947 divided the administrative functions of retailing alcohol for licensing. These changes created the fourth legal regime that beer-drinking Ontarians had to live with since the beginning of 1927. They represented a further unravelling of the temperance web of control. The LCBO was still able to announce in a publication in that year that there was no reason that Ontarians should not be able to buy what they wished if they were law abiding and financially able. It was still the role of authorities to determine those criteria.

Changes to the law were brought in by another change in provincial government with the Liberals being replaced by the Conservatives of George Drew in 1943. The new laws brought in by Premier Drew sought to distance his administration from allegations of political patronage in the distribution of licenses and also to respond to public attitudes. In April 1944, a Gallup poll indicated that 73 percent of Ontarians rejected any prohibition. The brewing industry was interested in public opinion as well. In public opinion polling undertaken in 1946 and 1947, attitudes of Ontarians were measured related to beer ads in the media, as well as the management of breweries and retail outlets for beer. The polling, conducted on behalf of Molson, captured postwar perceptions of Ontario's situation. A drop was noted from 90 percent to 80 percent on the question of whether beer was an intoxicating beverage. The shift was an even bigger drop for those under thirty. A great one-year jump from 40 percent to 88 percent was recorded for support for Brewers Retail stores, with far higher marks for their management compared to hotel beverage rooms.

These opinion polls captured not only postwar changes in public attitudes but also changes to the system of selling beer in Ontario that came into force on January 1, 1947. Announcing the new further relaxed regulations, Attorney General Leslie Blackwell confirmed that throughout the war years, beer consumption more than doubled from 24 million gallons in 1939 to 51 million in 1946. The old rules were described as "partial prohibition," and they were being "disobeyed by increasingly large numbers of otherwise law-abiding citizens." Apparently, the generation that wanted to get to work after fighting the war wanted a beer as well.

The changes in attitudes behind the polling reflects the social levelling that occurred through the years of economic depression followed by years of war. The moral superiority of adherents to sobriety was no longer an accepted norm. Brewers were involved. Labatt was staking a claim for beer as a normal part of life by placing ads in newspapers asking for public support of the St. John's Ambulance Society, sponsoring events like a UK food drive and organizing safe driving demonstrations at small-town Legions. Attitudes about beer had shifted such that by the end of the first half of the century, as Coutts describes, an Anglican minister could describe a room of beer drinkers in this way:

> *A fundamental norm is open acceptance of both idiosyncrasies of behaviour and moral outlook and different social types and races. Thus the handicapped, the man with no roof in his mouth, the half-breed, the negro, the wino and the transient, the prostitute, either pretty or emaciated, the homosexual, pimp or gambler are all accepted without stares or other forms of social ostracism.*

At the end of the first half of the twentieth century, Ontario was undergoing social transition. It was just a few years from the first human rights legislation protecting against discrimination in employment and accommodation. The Progressive Conservative Party was still in the early years of a forty-two-year run of uninterrupted power. The population of the province expanded more than 20 percent in the 1940s, and the economy was booming. E.P. Taylor controlled 50 percent of the provincial beer market, compared to 20 percent for Labatt. At the century's halfway point, Ontario's brewing industry and beer itself were changing to keep up with the race forward.

THE 1950s

The 1950s are not often looked back on with any particular fondness in Canada. In terms of markers for national pride, they are stuck between victory in the Second World War and Expo '67. In America, there were sports cars, rock 'n' roll and the predations of Madison Avenue. In terms of Ontario's brewing history, it is the decade in which Ontario beers and breweries began to extend their reach across the country and out into the world. It was also the decade in which important retail rules we live with today were established.

As might be expected, E.P. Taylor looked out into the world at the dawn of the new decade and saw nothing but markets and opportunities. In 1952, he added Quebec's giant National Breweries to his portfolio. National was the company born of consolidations that had first inspired Taylor's initial plans. In the same year, Carling's flagship Black Label was first brewed under contract in the United Kingdom. In the years that followed, he would expand operations in the United States and buy breweries in the western provinces. Taking on the challenge, Labatt bought breweries in Manitoba and British Columbia while building a new brewery in Montreal. Its brewery's original location in London also underwent large-scale expansion. Molson moved into the Ontario market in 1955 with the building of new 300,000-barrel-per-year brewery on Toronto's waterfront. The big players who would dominate Ontario for the next thirty years were established.

In the fall of 1950, fuelled by public perceptions of industry domination, Taylor's Canadian Brewing faced accusations of being behind a provincial price increase from twenty-three to twenty-six cents per bottle of beer. It faced a six-week boycott organized by the Hotel Proprietors Association. While the price increase was, in fact, a decision of the entire provincial brewing association, blame was laid at the feet of the biggest player. As a result of the jump in prices, drinkers in beverage rooms switched from bottles to draft beer, buying less than half the bottles they did before the boycott. While denying that there was an actual ban on Taylor's products, the head of the hotel group stated that "perhaps by coincidence there was a noticeable scarcity of O'Keefe, Carling and Brading brands in some Toronto beverage rooms Friday night."

The trend was toward modern, lighter beers as the flagship of a brewing empire. E.P. Taylor's lead brand was Black Label. It was joined in the 1950s by brands that are still available: Labatt introduced 50 Ale in 1950 and Pilsner (later renamed Blue) in 1951. Molson released Crown and Anchor

(later renamed Canadian) in 1954. Bigger beers like Labatt IPA and Molson Export Ale were still being brewed, but the days of these beers topping the sales of a brewery's lineup were at an end.

These new beers reflected a shift in consumption. Images and advertising from the era placed these lighter beers in the home, not the beverage room. The baby boom was taking place across the suburban landscape of Ontario, and TV was the new form of entertainment. By 1955, Ontarians no longer had to sign for their beer purchases when buying at Brewers Retail stores, the sole retail outlet controlled by the brewers. One politician, Hamilton MPP Arthur Child, proclaimed the good news in the provincial legislature in this way: "You can buy up to 10 cases a day and no identification is required… If you wanted to sign your dog's name, I imagine you could still get a fairly large quota."

From 1949 to 1963, beer downed in beer parlours and other public places dropped from just above half of all consumption to under 40 percent. The new brands were intended to take advantage of this development. The new scale of transportation and brewing in the 1950s ushered out the concept of regionally based brands just as a greater role for the federal government in society and a national identity on the global scene was developing. As Canada was beginning to shrug off the social vestiges of the British empire, Ontario was defining itself as the booming, if slightly square, centre of Confederation.

It is important to recall, as Thompson and Genosko discuss, in this race to the future that there were still many aspects of the Liquor Control surveillance society in place. In 1955, a resident of Brantford was visited by the police after the LCBO reported on a review of his recent liquor purchase history. The police arrived only to find that the alleged impropriety associated with home consumption of beer one weekend was just a family gathering for a baby's christening.

Despite the changes at Brewers Retail in 1955, LCBO surveillance and records in the 1950s were still being used to pursue cases of not only drinking and driving or bootlegging but also overindulgence and misspending of income. Until 1958, the LCBO permit card not only identified the buyer but also listed the buyer's purchases to ensure that one only bought what one should.

It was not just the eagerness of the enforcement system that still smacked of central control. Under the Liquor Control Act at the end of the decade, Ontarians were prohibited from possessing more than twenty-four pints of beer purchased outside Ontario. Brewers could have their licenses canceled

Labatt's employees, members of the United Brewery Workers Union, are seen here dressed up as clowns for the purpose of playing in a jazz band. When you work at a brewery, strange things seem like a good idea at the time. *Courtesy of University of Western Ontario.*

or suspended without a hearing for any cause deemed sufficient by the LCBO. The law generously allowed purchasers to take their beer back home, and the route home "need not be direct"—as long as the seal on the package containing the beer remained unbroken.

Change had also come to the industry through unionization. Membership had grown in numbers and militancy, as it had throughout Ontario's economy. In 1958, five hundred union members employed in Toronto's beer parlours won a strike against the hotel owners association. In the summer of that same year, the province endured a seven-week-long brewing industry strike. More than one thousand workers in the brewers' warehousing depots and retail outlets walked out, triggering a lockout of most of the workers in the breweries. Formosa Springs Brewery was not unionized at that time and operated at full capacity until it ran out of beer three weeks into the job action. Taylor was out of the country at the time of the unrest and might have, upon reflection, settled sooner to avoid the $100,000 that his brewing operations lost each day. The brewers association, however, stood firm in his absence and ended the halt in brewing on its terms. The Australian song "A Pub without Beer" reached the radio charts during the strike as a sign of the public mood.

In addition to labour unrest, there were difficulties for Ontario's brewing industry on other fronts. A federal investigation had been undertaken into the massive degree of consolidation that had taken place in Ontario. The thirty-six firms that had existed in 1930 had been reduced to five in 1958. The trial, which began on October 13, 1959, was based, in part, on records seized from the offices of Taylor's firms as well as from his home. Evidence was presented by the prosecution of a long history of aggressive price fixing, mergers, reduction in brand variety, vertical integration and an overall drive to create efficiencies on a massive scale that triggered wealth. The evidence summed up the state of the province's brewing to that date, painting a picture of how beer and brewing had been controlled in Ontario through the decades since the end of prohibition. Depending on one's opinion of the massive power of corporate interests, it is either an impressive story or a depressing one. The ruling issued by the court early in the next decade set the scene for the future.

All in all, by the end of the decade, E.P. Taylor's enterprises had reached new heights. He vacationed with provincial premier George Drew. In 1958, he traded his ownership interest in the Carling brand in the United Kingdom for a slice of a bigger pie, triggering the complete restructuring of the British brewing industry in the image of the consolidations that he had achieved in Ontario. As part of this plan, Taylor sought a 25 percent stake in every publicly traded brewery in Britain. In June 1959, he accompanied Queen Elizabeth at the prestigious Queen's Plate horse race. Prior to the political rise of Pierre Trudeau, Taylor was arguably Canada's most famous son, all based on an international empire founded and fed on Ontario beer.

THE 1960s

The ruling in *Regina v. Canadian Breweries Ltd.* was released on February 8, 1960. The case was based on dual accusations: price fixing and stifling control of the marketplace. It was argued that the result of the mergers placed the production and sale of beer in the hands of what Crown counsel termed the "Big Three": Canadian Brewing Ltd., Molson's Brewery and John Labatt Ltd. The court found that the share of the market enjoyed by Canadian Brewing Ltd. in Ontario rose from 11.2 percent in 1931 to 60.9 percent in 1958. Clearly, a massive shift in control of the industry had occurred.

The result was unexpected. The court found E.P. Taylor and his brewing empire not guilty. The judge stated that the evidence "establishes to my entire satisfaction that the board fixed the price at which beer was sold in Ontario at all levels throughout the entire period of the indictment." When it was arguing that the breweries of Ontario stifled competition, the focus of the prosecution was on how the brewers put roadblocks in the way of other brewers wanting into Ontario's marketplace through their ownership of Brewers' Warehousing. The judge did not agree, as it was the provincial liquor board that set the price. In any event, internal competition was strong with E.P. Taylor's business facing two "strong and aggressive" competitors that, between them, had 34 percent of total market share.

Because of the role played by the LCBO and the system of control of the brewing industry set out in the provincial regulations, the federal law had not been broken. What looked like a brewing cartel to many people was—in the eyes of the law—something less. The court determined that Ontarians were being well served by the provincial system. In a judgment best left to the consumer, the court even found that "the quality of the products is better than when the supplies came from a number of smaller breweries."

One advertisement from around the beginning of the decade announced that Labatt 50 was "Canada's fastest growing ale because it has SPIRIT!" It had so much spirit that one-sixth of the entire ad's text is made up of versions of the word. The brightly coloured image accompanying the text was of two happy couples smiling and laughing in a sailboat cruising at full speed. Beer, evidently, was for people who liked fun and lived the good life outdoors—people who could afford sailboats. Whoever they were, they were not men huddled in a dingy beverage room drinking glasses of draft, making some use of a few minutes between work and home. Whatever Labatt 50 was to the people on the sailboat, it wasn't the stout or IPA of the old days.

Most importantly, the ad isn't even about people drinking beer. It advocated a certain lifestyle in which beer was a prop. These ads were one of the few common forms of pop culture that were shared nationally, and what was defined as culturally "national" often represented the norm in Ontario. By the mid-1960s, stouts and porters were no longer part of the normal experience of Ontario beer drinkers. In a modern Ontario lifestyle, these styles of beer represented less than 1 percent of all sales. The culture, moving forward quickly, aimed at homogeneity.

Still, not all was smooth sailing and cool sophistication. In his 1968 poem "At the Quinte Hotel," Al Purdy described an Ontario beer parlour as a place of random brawling among drunks watched by comic book–reading

simpletons. The dull scene was broken by the poem's narrator first beating the biggest bully and then telling all gathered how beer was made of flowers. They did not really understand his message.

The standard stubby, the twelve-ounce beer bottle, was introduced in 1961. Although it was in use for only twenty-three years, it was an object that inspired huge affection among Canadians. Given that the beer the Big Three put in the stubby was becoming so completely uniform, it is not surprising that the glass packaging was the most distinctive element in the experience. Looking back, Douglas Coupland described the emotional connection:

> *Most pre-1980 garages have a few dusty stubbies tucked away in them somewhere. In order to get stubbies to photograph, I put an ad in the local community paper and was besieged by calls from fifty something men with a nostalgic lilt in their voices. They all wish that stubbies would return, but young people would probably look at a stubby and say "what's that thing supposed to hold—molasses?"*

Ontario's brewers continued to expand into other markets and diversify their investments throughout the 1960s. Labatt acquired the Saskatoon Brewing Company in 1960 and the Bavarian Brewing Company Ltd. of St. John's, Newfoundland, in 1962, and it opened a new brewery in Edmonton, Alberta, in 1964. Labatt also invested in research and the pharmaceutical industry and gained controlling interest in a number of wineries. Under the guidance of W.H.R. Jarvis, the first president of the company not related by blood, Labatt had expanded its total annual brewing capacity to 1.3 million barrels by 1965. The biggest change of the decade came in January 1966 when E.P. Taylor stepped down as the chairman of Canadian Breweries Ltd. He sold off his holding company's shares in the brewing conglomerate in 1968.

As early as 1966, cracks were appearing in the public's desire to feed the finances of Ontario's Big Three brewers. Unofficial Canadian poet laureate Al Purdy had been home-brewing beer since at least the mid-1950s. Apparently, a child had fallen into his brewing bucket under the kitchen table, eliciting the now famous line, "Keep your ass out of my beer!" Home-brewing in Ontario was officially acknowledged in 1966 in a regulation brought into force under the Liquor Control Act that simply stated, "Any person brewing for use of himself and his immediate family under the Excise Act (Canada) may have or keep the beer only in his residence."

Other forms of rejecting the new lifestyle were being expressed. Ontario still retained the local option at the municipal level. Resorts and certain other

recreation facilities were exempted from the local vote requirement in dry municipalities, but this created the odd situation where tourists could drink while residents were barred. Special-occasion permits were still needed in these areas when beer and other drink were to be served. It was not purely a rural phenomenon, as anti-alcohol politician and activist William Horace Temple led a successful battle that kept the Junction neighbourhood dry in the west end of Toronto.

At the end of the 1960s, Ontario was in the middle of a period of heightened national pride accentuated by Expo '67. The pride would continue with the 1972 international hockey series against the Soviets and the 1976 Montreal Olympics. National universal healthcare coverage had become part of daily life. The CBC broadcast from coast to coast in colour. Canadians returned to a level of alcohol consumption that comfortably matched pre-prohibition levels. The province's beer parlours now competed against cocktail lounges with live music, although most Ontarians drank their beer at home. Ontario's beer was becoming more and more the nation's beer, and decisions affecting Canada's brewing industry were more frequently made in the province's corporate boardrooms.

1970 TO 1984

The climate in Ontario at the beginning of the 1970s was one that supported relaxation of the existing alcohol laws. In July 1971, the legal drinking age was lowered to eighteen from twenty-one. The sudden inclusion of teenagers in the crowd at the beer parlour must have been a shock to regular customers. They remained there until 1979, when the drinking age was raised to nineteen due to concerns over now legal drinking by high school students. Additionally, the ban on Sunday sales was lifted. Further changes to the licensing laws came a few years later. During an agency review headed before a committee of Ontario's legislature, the head of the Liquor Licensing Board of Ontario described the changes brought into force in the mid-'70s: "The modern liquor legislation dates back to 1976. It was at that time that a license became a right rather than a privilege. That right is qualified in the act, but that represented a major change and all those who are affected by decisions of the board, all parties, are entitled to a hearing before the board."

Early on, the '70s saw the continuation of the boom period of postwar optimism and expansion. Labatt opened a new $13.5 million plant. Canadian Breweries focused its attention on the north with the purchase of North Bay's Northern Ontario Breweries. Some variety was introduced in the 1970s. Molson Brador was a great success as a malt liquor. Newcomer Henninger, operating out of what had been the Peller plant in Hamilton, sold Meister Pils, a European pilsner. Canadian Breweries brought the Carlsberg brand to Ontario and competed directly against Molson's Brador with Colt 45 malt liquor.

Each of the three big breweries introduced a light beer brand aimed at a new generation of drinkers. To this generation in the late '70s, beers like Labatt 50 and Black Label, which were flagships decades before, seemed dated and irrelevant. They were what beer writer Paul Brent has called "Dad's Beer." Unlike the 2.2 percent temperance light beer introduced in 1924, the new light beers were universally 4 percent ABV, just 20 percent lighter in strength than regular beer. The concept ran into the law, however, as the first of these light beers, Labatt's Special Lite, landed in front of the Supreme Court of Canada. The government had prosecuted because, by definition, as a product category, light beer could only have 2.5 percent alcohol.

Labatt won its case. It was held by the court that the federal authority over criminal law had no authority over the beer labels of the nation. Still, sales of these new light beers initially suffered somewhat from the cultural stigma that lower-strength American beer still carried, especially with the ale drinkers in Ontario and eastern Canada. While the court had chipped further away at the outdated brewing regulations, the scene was still a strange one to an educated outsider. In the first edition of his 1977 book *The World Guide to Beer*, Michael Jackson questioned how the system had come to be give the early makeup of the country: "This cannot be attributed to the preponderance of Scots in much of Canada, since the restrictions on alcohol are more reminiscent of those in Norway, Sweden and Finland."

After mentioning gender-divided beer parlours and government price controls, Jackson also noted that Ontario was still drinking 56 percent ale and had access to older styles such as porters, stock ales and export ales that he described as firmer, stronger or even slightly sweeter than beers to be found south of the border. By his count, the entire nation was supplied by six breweries producing just over one hundred brands. Three of the breweries were headquartered in Ontario: Labatt, Carling and Henninger.

European breweries began to take an interest in Ontario's beer market. In 1973, Henninger had purchased the old Peller Brewery in Hamilton from

Canadian Breweries Ltd., which had operated it as a Brading and then Carling plant. Henninger promised in its ads that the pilsner it was brewing in Ontario was exactly the same as the one it had been brewing in Germany since 1880. It even claimed that the yeast strain was flown over in a special jet service from its Frankfurt brewery. Henninger would only last until 1981, when Heineken's subsidiary Amstel would take over the old Peller brewery.

Labatt invested heavily in sports franchises in the 1970s to associate its beer with the active lifestyle it portrayed in its advertisements. In 1972, it brought grand prix auto racing to Canada. In 1976, the brewery was a 45 percent shareholder in the Toronto Blue Jays expansion franchise. In 1978, Labatt sought to buy the Montreal Canadians, only to lose out to Molson's bid. The same year, Labatt began its sponsorship of the Brier, the national men's curling championship. Spectator sports, advertising and beer had converged for Labatt to place itself prominently in nationally televised popular culture.

As the late '70s became the early '80s, beer ads and slogans had become a wasteland of monosyllabic generalities. Labatt Blue's "Smiles Along with You" competed with Molson Light's "You Gotta Have Heart" or Molson Export's "Ex Says It All." Labatt 50 piled on with "You Can't Say Beer Any Better." Whereas a few decades before, lifestyle beer ads had asked Ontario to think about beer in the larger context of their lives, the current message was for consumers to stop thinking about beer altogether. These were similar ads for similar beers for similar people having similar experiences. Beer in Ontario had hit its all-time low, and it was reflected in the sloganeering.

A number of changes in the early years of the 1980s suggested that the market had reached saturation. In the taverns and pubs, the experiment with happy hour from 1981 to 1984 was a social flop. Concerns with a return to the old days of too much beer being downed between work and home were accentuated at a time of increased social disapproval of drinking and driving. The provincial anti-drunk driving organization People to Reduce Impaired Driving Everywhere (PRIDE) was founded in 1982.

Canadian beer brands that had come from Ontario were decreasing in popularity. American brands Bud and Miller were brought to the province in the early 1980s, brewed under license by Labatt and Carling, respectively. With increasing exposure to advertising from the United States over the airwaves, interest in familiar brands necessarily waned. The venerable stubby began to be replaced by the twelve-ounce long-neck bottle in 1983. Even though the new bottle was roughly the same shape as the pint bottles used before the '60s, the introduction was associated more with contemporary

cousins from America. North America was becoming increasingly culturally homogenous, and the choice of bottle reflected that fact.

There was one last display of a sort of pride in Ontario's industrial beer. For a few years, Bob and Doug McKenzie were among the most well-known comedy duos in North America. As a regular feature of legendary sketch comedy programme *Second City Television* (*SCTV*), the McKenzie brothers appeared on the CBC in Canada and then late Friday night on NBC across the United States. In each short episode, the brothers from a suburb near Toronto gave their drunken thoughts on a topic in the news while smoking, drinking and grilling back bacon for sandwiches. On the set, cases of stubbies from both Molson and Labatt were featured prominently next to an outsized map of the country.

Played by Rick Moranis and Dave Thomas, the skits spun out a top-selling comedy album, a hit single featuring Geddy Lee from Rush and a feature movie, all largely centered on their love for and dependency on Canadian beer. While Bob and Doug represented a lot that we recognized in ourselves, our dopey co-workers or our second cousins, in the end they did not represent the future the Ontario beer drinkers imagined for themselves. They were ultimately a caricature that hit a little too close to home. Everyone knew someone who fit the bill of the stereotypical toque-wearing stubby guzzler. If anything, they represented unthinking consumption. There was no single brand of beer that they consumed. They viewed the product merely as a commodity. It was a more honest portrayal of the lifestyle that beer drinkers actually lived than the Labatt ads of the 1970s. As much as anything, they illustrated an evolutionary cul-de-sac. In the same way that traditional brands of beer and little stubby bottles were being rejected, Ontario wanted to move on from this image of itself.

CHAPTER 7
THE BREWERY NEXT DOOR

1984–2014

The first brewery of the modern era in Ontario was founded by Jim Brickman in 1984. Waterloo's Brick Brewing Company was the first small brewery to open in the province in decades. Some regional breweries had transferred between owners, but Brick's decision to start up in a converted furniture factory was a novelty. The initial investment was $2.5 million and allowed for the production of 4,500 hectolitres of beer in its first year. For the sake of comparison, that amount of beer might have amounted to a week's production at the gargantuan Labatt plant a few doors down. When the totality of Labatt's output in Ontario was taken into account, Brick's volume was miniscule.

Brick's location nicely defined the spirit of the developments of the next thirty years. In the face of overwhelming volume, a retail monopoly, advertising budgets that would shortly climb into the range of hundreds of millions and a public that found the bland mass-produced beer good enough, Brick would compete anyway.

The mood of the citizens and the government of Ontario shifted dramatically in the spring of 1985. A lockout of employees from the three largest brewers in the province meant that Molson, Labatt and Carling O'Keefe were producing no beer. In addition, their nearly wholly owned subsidiary, the Brewer's Warehousing Company Ltd., was also locked out. The province of Ontario spent the entirety of the month of March without access to the beer to which it had become accustomed.

While it might have been an afterthought for the large brewers at the time, it was not as though there was a complete absence of competition.

Ontario's first microbrewery, Brick set up shop in 1984. At one time, it was lauded for its Anniversary Bock, but its core focus now is on discount brands. *Courtesy Wikimedia Commons.*

As stock dried up across the province, people sought out the beer made by breweries that were still open. Hamilton's Amstel plant was unaffected. Northern Breweries, which had been purchased by its employees in 1977, had no use for a union and was similarly nonplussed.

The recently opened Brick Brewery was affected to the extent that it sold out completely before the strike began in earnest as beer drinkers stocked up. The shock caused the brewery to purchase storage tanks for expansion. Northern Breweries' supply lasted until March, and it would subsequently advertise for the return of its bottles. Hamilton's Amstel plant did likewise. Its brewmaster was quoted in the *Globe and Mail* as saying, "No empties, no beer."

Ontario beer drinkers, faced with calamity, did the unthinkable: People from Ottawa drank in Hull. People from Windsor drank in Detroit. Where the LCBO stocked American imports, the imports quickly sold out. The large brewers had forgotten an important fact about beer: they are at least as dependent on their consumers as their consumers are on them. At the time, with the market nearly completely under their control, as it had been since the 1950s, they assumed that there would be no consequences to their action. After all, what could beer drinkers do about it?

The lockout crippled any goodwill that the public had for the large brewers, and the newly elected Liberal government of the province under David Peterson began to seek out small changes to the status quo. While the political will did not exist to make good on Peterson's campaign promise to sell beer in grocery and convenience stores, there were actions that the public supported. By May, the laws surrounding home-brewing had been updated. One no longer had to have written permission from the government to brew for personal consumption. By October, brewpubs had become legal. Alternatives to the large brewers would be kept in full view of the public due to a strike of Beer Store employees in the summer of 1986.

It is not as though microbreweries sprang up in great numbers overnight. It also cannot be claimed that they were necessarily interested in producing what we would now think of as craft beer. In many cases, the intent was simply to provide a local alternative to corporate brands that no longer adhered to a sense of place. Labatt may have been an Ontario property to begin with, but its flagship brand was named for a football team from Manitoba. Carling O'Keefe had never been strongly regionally identified to begin with since its corporate structure was the result of so many mergers and acquisitions. It had many brands, but none really captured the imagination of the public.

In 1985, both the Wellington County and Upper Canada Brewing companies opened their doors. They could not have been more different in their aspirations. The ambition of Wellington's founders was tempered by the success of CAMRA within the United Kingdom and came with a vision of locally produced real ale in casks. It was very much designed with English styles of beer in mind, to the extent that much of the lineup remains unchanged to this day. Its Arkell Best Bitter and County Ale still grace hand pumps around the province today. Its original output of four thousand hectolitres has increased, but it has been over the span of thirty years.

Upper Canada, while adhering to the limited ingredients of the Reinheitsgebot (the German beer purity law), was more commercially minded. Its initial lineup in June 1985 comprised a lager and a dark ale. In a sign of its willingness to cater to the market, it added a light lager in 1986. Its production level for the first year was four thousand hectolitres, but by 1993, it was producing ten times that much beer and was 40 percent owned by Corby Distillers. The idea was that expansion would continue, and Upper Canada would become oriented to the export market. It was diversifying, providing contract-brewing services for brands both local and international. At one point, it produced an adjunct lager called Sichuan Snow Waves from a brewery in Chengdu in China.

The following decade, which contained what you might think of as the first wave of microbreweries in Ontario, was very much defined by its failures. Perhaps it was that there had been no local breweries for decades, and the public was simply unused to beer with character. Perhaps it was poor capitalization on the part of the owners, compounded by the lengthy recession caused by the savings and loan crisis of 1987. Perhaps it was simply a lack of expertise on the part of the entrepreneurs and the desire to accomplish too much too quickly. It is a testament to the difficulty of operating a brewery in the period that there were breweries that did not last long enough for even serious beer drinkers to register their existence.

Great Lakes opened in Brampton in 1986 and lasted four years before declaring bankruptcy, only to be reopened by Peter Bulut Sr. in 1992. Conners, an iconic brand from the period, also filed for bankruptcy in 1990 after consolidating its production at a single facility in the Don Valley. Reopened in 1992 in St. Catharines, it managed to hold on until 1995 before being purchased by Brick.

Farther away from the large market of Toronto, the lifespan was even shorter. The Simcoe Brewing Company of Newmarket lasted two years, as did the Halton Brewing Company in Burlington. The Ottawa Valley Brewing Company lasted three years in Nepean. Chatham's Wheatley Brewing lasted two years. The Sculler Brewing Company in St. Catharines managed two as well. Even appeals to nostalgia failed to secure success as the Bixel Brewing and Malting Company lasted just under a year. Taylor and Bate would open in Elora and manage four years under its historical moniker before closing. Many others cannot be named here for the sake of brevity.

There were success stories as well. Creemore Springs, founded in 1987, did well enough on the strength of its lager and its clever marketing to manage an eighteen-thousand-hectolitre expansion in 1993. The strategy of making a single product helped it immeasurably, as did hiring an experienced brewmaster.

Sleeman, which opened in 1988 in Guelph, was properly capitalized and had eyes on a 2 percent market share in the province—a goal that no one else would dream of. Sleeman produced 200,000 hectolitres per year by 1993, making it the biggest player in the microbrew market. It was part owned by Stroh's of Detroit, which lent the company a certain degree of financial stability. The appeal of a long-dead brand being resurrected by the great-great-grandson of the original brewer certainly helped with public reception.

Algonquin, while capitalized sufficiently to avoid immediate problems, suffered badly as the result of the GATT and NAFTA trade agreements that

saw exports to the United States rapidly lose any semblance of profitability. The decision to dedicate a healthy amount of its volume to twenty separate states when a market remained to be conquered at home was a predictable Achilles' heel, although the sudden increase in service fees at the Beer Store, which crippled its cash flow, was unforeseeable. The 100,000-hectolitre facility, which dated back to the 1870s, was purchased by Brick in 1997.

For a time, brewpubs fared rather better than production breweries in terms of longevity. Although they were made legal in October 1985, the first didn't open its doors until the spring of the following year. The race to acquire a license was a crowded one, with five competitors looking for that privilege. Ultimately, the winner would be the Atlas Hotel in Welland, which provided the additional draw of a downstairs lounge with exotic dancers. If ever there was a sign that the restrictive mores of the beer parlours at mid-century had been abandoned, this was it.

The brewpub came with difficulties of its own. At the time, the annual production was limited to two thousand hectolitres, an amount that a busy location might eventually find limiting. Additionally, the incorporation of a restaurant with a brewery made the business increasingly risky. Roel Bramer of the Amsterdam and Rotterdam brewpubs in Toronto had this prescient take on the matter in the *Toronto Star*: "I don't think the brewpub itself makes the place a success. If your food's no good and the beer's no good and the service is no good, a brew pub isn't going to save you."

In the majority of cases, the brewpub became a liability as malt extract brewing systems were the norm. The staggering popularity of the brewpub as a concept meant that everyone wanted in on the act, and extract brewing was the shortest and most affordable route. Jamie MacKinnon, writing in his 1993 *Ontario Beer Guide*, predicted that there would be fifty brewpubs in Ontario by 1995. It was a thoroughly reasonable assumption based on their growth up until that point.

It was not a phenomenon that was entirely centralized around Toronto, although Toronto had its share. At one point in the early 1990s, Toronto had at least ten in operation, four of them located on a half-mile stretch of Eglinton, east of Yonge Street. It was a widespread trend, the appeal being that a small extract brewpub system could be dropped into an existing facility without much in the way of expense. They stretched from one end of the province to the other, from Charley's in Windsor to Master's in Ottawa. It wasn't even limited to southern Ontario, with Thunder Bay, Sault Ste. Marie and Orillia getting in on the act. You will not be surprised to learn that a trend that was defined by the ease of use of extract brewing systems

A perennial feature outside the brewpub, the Kingston Brewing Company's wagon is a throwback to the more glamorous beer delivery methods of the 1930s. *Courtesy of Ben Johnson.*

was of wildly variable quality, gravitating in the case of the worst offenders toward borderline undrinkable.

The survivors were typically those that brewed with grain and acquired enough expertise to produce high-quality beer reliably. Amsterdam would eventually turn its sister pub, the Rotterdam, into a production facility. The Granite Brewpub, with its Best Bitter Special and Ringwood yeast character, remains a destination to this day. Denison's complex of pubs on Victoria Street lasted long enough to do its investor, Prince Luitpold von Bayern, proud. An exception to the rule was the Kingston Brewing Company, which maintained an extract system for brewing on site but whose flagship brand, Dragon's Breath Pale Ale, was so popular that it had to be contracted out to Hart Breweries of Ottawa in order to keep up with the Eastern Ontario demand.

From the point of view of the consumer, especially in the 1988 economy, a good response to the state of beer in Ontario was the development of "brew-on-premise" establishments. Also know as "U Brews," these businesses allowed citizens to exercise their right to brew for personal purposes in a collective setting with better equipment than they could afford at home.

From a legal standpoint, all of the participation that was necessary on the part of the customer was the pitching of the yeast into their batch of beer. The level of involvement would vary depending on the level of interest of the customer.

The main attraction of the U Brew outlet was the significant savings to the consumer, with basic ales and lagers frequently coming in at half the price of a case from the Beer Store. At a time when the minimum pricing for a case of beer (about eight litres) in Ontario was just under twenty-four dollars, it was possible to produce six times that volume for just over two and a half times that price.

Additionally, the variety was greater, with more interesting styles of beer than were available commercially, as well as clone recipes designed to emulate products that consumers couldn't justify shelling out for. One Whitby shop in 1993 offered more than forty styles of beer. The beer-buying public was interested in a range of flavours that commercial brewers were simply unable or unwilling to produce at a price the public was willing to pay.

The brew-your-own fad peaked and then faded quickly once other interests got involved, but at its height, the leading chain, Brew Kettle Corp., was traded publicly and had franchises in Australia and the United States, making it second only to Brick in offering an IPO. At a 1996 federal hearing on taxation of major Canadian industries, Sandy Morrison, president of the Brewers Association of Canada, complained about the lack of any imposition of taxation or regulation on the brew-on-premises trade:

These brew-on-premises outlets now have an 8% share of the British Columbia market and a 3% share in Ontario, which is the largest beer market in Canada. In total, they account for about 10 million dozen-cases of beer a year. The production from these unlicensed, unregulated mini-breweries exceeds that of the micro-breweries across Canada, and certainly in the two provinces concerned. The brew-on-premises outlets started ostensibly as a way to allow hobbyists to brew their own beer in a remote facility.

The association president went on to note that brew-on-premises business had developed into a full-scale commercial operation that focused on government alcohol tax avoidance, noting that the loss of taxation revenue in just Ontario and British Columbia totalled $69 million when the provincial and federal levels were combined. Soon thereafter, the law was changed, and regulations, as well as taxes, were applied. Costs were passed on to the

citizen brewers, and as might be expected, interest in the hobby faded just as the economy picked up and roared in the 1990s. As an unintended side effect of their thrift, beer drinkers and many future microbrewers developed education and discernment fifty litres at a time.

Another response to the recession of the early 1990s was the growth of discount brands within Ontario. While the Amstel plant in Hamilton had been producing Laker since the previous decade, it was ultimately the takeover of that plant in March 1992 that would see the brand become a household name in Ontario. Sharpe had been an executive with Carling O'Keefe and saw the chance to take over a floundering operation with a 330,000-hectolitre production as a door to sales in Ontario through private labels. He would call it Lakeport.

The initial foray into the market came with the Around Ontario brand, but the real change came on the strength of Loblaw's pitchman, Dave Nichol, who would introduce PC Premium Draft Beer to complement the President's Choice label. The combination of the high regard in which the public held Nichol and the price point of his beer, which was nearly two dollars lower per case of twelve than the core Molson and Labatt brands, was enough to claim 2 percent of the Ontario market within six months. Add to that agreements to brew Pabst Blue Ribbon and Lone Star, and within a year, Lakeport would make it 4 percent.

In 1989, Molson had merged with Carling O'Keefe, which in turn had been purchased in 1987 by the Australian firm of Elders IXL Ltd. The merger gave Molson 53 percent of the national beer market and made it the sixth-largest brewery in North America. Labatt was not very far behind to begin with and less so once the necessary consolidation of Molson's large brewery plants took place across Canada. The merger saw seven closures as a result of redundancy. By the summer of 1993, Molson and Labatt were nearly equal, after Labatt divested itself of the Ault dairy properties.

At about the time that Lakeport's PC and contracted brands began to gain market share, Molson and Labatt were involved in a war over "ice beer." Although Labatt had patented the technique for brewing ice beer, Molson beat it to market, albeit with an inferior product. By August, Labatt's version had captured a 10 percent market share in the province, and it was ready to launch a higher-alcohol version: Maximum Ice, complete with a ludicrously bombastic commercial featuring Canadian actor Michael Ironsides.

The problem was that Lakeport's success couldn't be allowed to go unanswered. It had been years since anyone had managed to capture a 4 percent market share, and both Labatt and Molson found themselves

caught up in rear-guard actions for a market category that they had not created and did not especially want. Lakeport's products had two real strengths. The first was that the quality of its beer was, if not exceptional, at least dependable. The second was that the core feature its audience cared about was the fact that it was the cheapest beer on the shelf. It meant that Molson and Labatt, with their hundreds of millions of dollars in advertising budget, would have to compete in a place where that meant nothing. By competing in a segment defined by price, it legitimized the idea that brand loyalty was increasingly meaningless.

By the summer of 1994, the discount beer segment had stabilized at about 14 percent of the market. That summer, Master Choice, the house brand for the A&P supermarket chain, would join the stable at Lakeport with two brands. In the fall, Labatt would buy the contract for the President's Choice beers out from under Lakeport. Lakeport responded with a separate lineup endorsed by its former pitchman, Dave Nichol, and the reintroduction of the Laker brands, which had been brewed during the Amstel ownership of the plant.

In 1996, facing financial hardship, Sharpe sold the Dave Nichol and Laker brands to Molson, which in turn sold them to the Brick Brewing Company. So little did consumers care about the character of the individual beers in the category that Sharpe was able to continue to brew all of the Laker recipes under the name Lakeport. With each brand introduced, the discount category grew. With each additional choice facing consumers, the concept of brand loyalty suffered. In three years, the discount category had 17 percent of the market.

Throughout the 1980s and early 1990s, Labatt had been very successful, but dominance in a mature beer market doesn't permit much in the way of growth. Consider the lengths to which it was willing to go in order to sell more beer to the public: While it had always had a stake in the Toronto Blue Jays, it managed to create the Sports Network in order to broadcast the games to a wider audience. From November 1991 to June 1995, Labatt owned 90 percent of the Blue Jays team and was directly responsible for funding both of Toronto's World Series victories. All of this activity was to take a small percentage of an already flooded market in which people were drinking less beer per capita.

The year 1995 would see a bidding war for Labatt's takeover as analysts suggested that the business was not adequately leveraging the parts of the business that were not related to beer. By 1995, globalization of the brewing industry was becoming a fact of life. In some ways, it's a mercy that Labatt

was eventually purchased by Belgium's Interbrew in a $2.7 billion deal. The next-highest bid was made by Onex, which had no experience with the beer market and would likely have streamlined the company to optimize profit. Interbrew may have had the intention to use Labatt's facilities as a cat's paw to reach the American and Mexican markets, but it knew the business at the very least.

The question remained about why Labatt was not attempting to expand its business internationally through corporate acquisitions, as E.P. Taylor had managed with Carling. As analyst Douglas Goold put it in the *Globe and Mail*: "Why is one of Canada's two big brewers being taken over by a low-profile, less profitable European brewer?…Were the millions spent on sports and entertainment a costly digression? Indeed they were. That digression has cost Labatt, founded in 1847 by John Labatt in London, Ont, its independence." The last of Ontario's nineteenth-century breweries was no longer owned by Canadians, and had you asked the man on the street, he would have told you that a Joe Carter walk-off home run victory was a small price to pay.

If the period of brewing resurgence in Ontario up until the year 2000 can be said to have a winner, it is Sleeman. Its bid to take over Upper Canada in 1998 was ultimately a success, happening mostly due to the fact that Upper Canada controlled very little of its own stock. Its IPO in 1996 was greatly less successful than was hoped, with stocks ending the year at slightly over half its initial purchase price. Sleeman swallowed one of its largest remaining competitors and shut down Upper Canada's Toronto brewing facility. It had already taken over Okanagan Springs in British Columbia and would go on to take over the Maritime Beer Company in Nova Scotia. Sleeman would end the twentieth century as the third-largest brewer in the country.

The globalization of the brewing industry that started in Ontario with E.P. Taylor had come to define most facets of the Ontario beer market. The main distributor, the Beer Store, was owned by the largest companies and dealt with an economy of scale that could prove ruinous to small players. The advertising budgets of the large brewers could create advertisements that have become legend. Molson Canadian's "I Am Canadian" rant was influential enough that it is still aped to this day. Further, the poor success rate of microbreweries and brewpubs in the 1990s left an indelible mark on consumer confidence in that sector.

Microbreweries began to fill out the landscape between 1995 and 2000, but at a much slower rate than previously. Small brewers might have been in

the same industry as Labatt and Molson, but they had been disabused of the notion that they could compete directly. In many ways, the best policy was to create stable products with broad appeal that would find support locally, avoiding the Beer Store when possible. Breweries might offer two or three brands, and while they would be of fairly high quality, they would be an ale and a lager. The watchword was *caution*.

To give some idea of the serious impact that the failures of the 1990s had on Ontario brewers, one need only look as far as Steam Whistle. The business model was as streamlined as possible, with a single beer on offer—a fact that the motto "Do one thing really, really well" reflected. The location of the brewery ensured foot traffic from the nearby Skydome, which helped with the distribution problem. Perhaps most importantly, the monogram on the packaging, 3FG, an abbreviation for "Three Fired Guys," served as a daily visual reminder to the founders of the ultimate fate of Upper Canada.

A sign of the direction that small brewers would take came in the form of historical recovery. When Algonquin renovated the Formosa Springs Brewery in the 1980s, the attempt was to recapture the scale of success of the mid-twentieth century. The projects of the late 1990s were of a smaller scale and reflected local rather than national ambitions. Andrew and Val Stimpson would resurrect the Crystal Springs Brewery at Neustadt, originally built in 1859 by Henry Huether. The Adlys family would reopen the Lion Brewery in Waterloo at the Huether Hotel, carrying on a local brewing legacy that stretched back to George Rebscher.

Positive change came in 2003 with the founding of the Ontario Small Brewers Association, originally headed by Gary McMullen of the Muskoka Brewery. If the small brewers in Ontario were fairly separate geographically, they at least had the commonality of experience of the Ontario market—of facing a system that was inequitable to the small businessman. By banding together, they were able to combine their efforts in lobbying the provincial government and in reaching a larger audience within Ontario.

Rebranding to the Ontario Craft Brewers in 2005, advances were made mostly in terms of stability for the small breweries. Speaking in 2007 about its first sample six-pack representing member breweries, McMullen might as well have been talking about the organization's strategy when he said, "We took a cautious approach with this, but there's plenty of time to explore more styles. This isn't a short-term thing."

In 2008, support would arrive from an unlikely candidate: the Speaker of the Legislative Assembly of Ontario. Steve Peters instituted an annual beer tasting at Queen's Park in Toronto to showcase the quality of the beer being

Contract brewers like Paul Dickey of Cheshire Valley, pictured here, have been instrumental in the diversity of the Ontario beer scene since 2008. *Courtesy of the author.*

produced within the province. It was something of a coup in terms of the visibility of an emerging industry to individual members of the government of Ontario. Public awareness was certainly beginning to increase, although the selection of products on offer was still relatively limited.

While events like the Toronto Festival of Beer went some way to showing off the products of breweries from around Ontario, one event has been more formative than any other in the rapid expansion of Ontario's small brewers. Initially held at Bar Volo in 2005, Cask Days has for the last decade served as the yardstick for the progression of Ontario's craft beer. From its first year, Cask Days provided something that had not existed in a formalized way: an opportunity for playful experimentation in front of a self-selecting audience.

In 2005, there was very little selection in terms of different styles of beer. Etobicoke's Black Oak had been releasing seasonal brews like the Nutcracker Porter since 2001, and others had followed suit. Ottawa's Scotch Irish, headed by Perry Mason, began production of the properly hoppy Sgt. Major IPA in 2002 and released Tsarina Katarina Imperial Stout in

Left: The inclusion of small brewers in festivals like the Toronto Festival of Beer has helped with the mainstream appeal of craft beer. Ken Woods of Black Oak is pictured pouring his Double Chocolate Cherry Stout. *Courtesy of Ontario Craft Brewers.*

Below: Ralph Morana is the driving force behind Ontario's Cask Days festival, which is considered one of the finest beer festivals in North America. In recent years, he has been ably assisted by his sons, Tomas and Giuliano. *Courtesy of Mikael Christensen, SJWJR3.*

Great Lakes brewer Mike Lackey with the fermenter for his pilot system. *Courtesy of the author.*

2005. Mill Street would annually release its Barley Wine in a special ceramic bottle. Aggressively flavoured and seasonal beers were still very much in the minority. It was improbably expensive to stock seasonal products in the Beer Store, meaning that a significant distribution run would have to go through the LCBO or direct sales.

The LCBO's beer selection began to improve greatly as the sole affordable distribution channel within the province. An early adopter of this avenue, Great Lakes' Devil's Pale Ale, is also a good example of the change in attitude that began as the result of a coalescing provincial beer scene around 2007. For one thing, it came in a can, a comparatively uncommon choice for craft beer at the time. For another, it was visually distinctive with its road sign gimmick. It did not adhere to a basic style. It was dark, but it was aggressively hopped. It was, finally, more creative than cautious.

By 2008, things had improved markedly. The LCBO was providing a reasonable volume of distribution for craft beer. Brewers were finally beginning to emerge from under the shadow of Ontario's early failures. Funding from the provincial government was a reality. Most importantly, the audience for their products was growing.

Social media would prove to be the most impactful technological advance for beer in Ontario since the advent of rail. When television was the most

important form of communication, advertisements like the "I Am Canadian" rant could reach of millions of people if run at the right time of day. For a generation that experiences the world through Facebook and Twitter, who curate their online experience and select who will advertise to them, craft beer is an attractive prospect. It is an opportunity to express individualism in a limited way. These technologies proved incredibly useful as breweries with limited advertising budgets could compete in a medium where the lack of funding actually suggested authenticity.

Additionally, a number of writers took advantage of the medium to inform the public about the beer being offered as the beer scene came together. Veteran writers like Stephen Beaumont and Nick Pashley were joined by columnists like Josh Rubin from the *Toronto Star* and Aonghus Kealy from the *Toronto Sun*. Talented amateurs like Greg Clow of *Canadian Beer News* and Troy Burtch of the "Great Canadian Beer Blog" would begin to wield a substantial amount of influence. Where previously, information about the expanding scene had been concentrated on forum-based websites like Cass Enright's Bartowel.com, it was now disseminated to the public along with some indication of why it was important economically and socially.

The most common criticism of Ontario's beer in the last decade has been that the industry lags behind the United States. This was certainly true for a time, but the period of expansion that has taken place since 2008 has been vastly impressive, consisting of the single largest amount of activity in the history of the province's brewing industry. In some cases, growth has come in the form of talented amateurs making good and going professional, as in the case of House Ales' Eric Ecclestone or Beyond the Pale's Shane Clark. In others, it has come simply from experienced brewers splitting off and taking on the challenge of opening their own places, as it did in the case of Toronto's Bellwoods Brewery.

Perhaps the most important development has been the opening of Niagara College's brewing program, which has seeded the province for the first time with locally trained brewers who are entering into the industry with their eyes open. They benefit from the wisdom of instructors like Jon Downing, who opened the province's first brewpub and who witnessed firsthand the difficulties of craft brewing in its infancy. Although it has been but a short time, the results are already evident, with graduates contributing to new properties like the Indie Ale House, Left Field and Sawdust City.

For the first time in decades, an active agricultural industry has sprung up to meet the needs of Ontario brewers in the form of the Ontario Hop Grower's Association. Dozens of hop varieties are being grown in the

Beer writers and bloggers have been accelerants in the recent craft beer boom. *Left to right*: Nicholas Pashley, Stephen Beaumont, Troy Burtch, Aonghus Kealy, Josh Rubin, Greg Clow, Ian Coutts and Robert Hughey. *Courtesy of Stephen Gardiner/Toronto Beer Week.*

Contract brewers like Dmitri van Kampen from Spearhead, pictured here, have been instrumental in the diversity of the Ontario beer scene since 2008. *Courtesy of the author.*

province, including the indigenous Bertwell strain, which has been the project of Mike Driscoll, a former brewer himself. In some cases, like that of the Gananoque Brewing Company, custom malting of locally grown grain is being performed to enhance specialty brews.

Steve Beauchesne, of the rapidly expanding and ever popular Beau's All Natural Brewing Company in Vankleek Hill, once remarked of the period before the boom that "there was a sense in Ontario that if no one was doing it, it couldn't be done." That is no longer the case. Ontario's brewers have outgrown their timidity, and it shows in the quality and inventiveness of the beer on offer.

At the time of Confederation, Ontario had about 150 breweries. At the time of this writing, early March 2014, Ontario has 94 brewers or contract brewers. There are currently 50 more in planning. It is likely that, by Canada's 150th birthday, Ontario will support more brewers than it ever has in its history. Because of the inequitable distribution system that twentieth-century consolidation created, the breweries will focus on local custom, and a map of their placement in the province towns is practically identical to that in 1867. Progress has been achieved by moving backward.

The quality of the beer being brewed in Ontario has never been higher than it is at this moment. The selection has never been this great. After four centuries of beer and two centuries of industrial brewing in the province of Ontario, we have entered its golden age.

SELECTED BIBLIOGRAPHY

Beaumont, Stephen. *Great Canadian Beer Guide*. Toronto: Macmillan, 1994.

Bellamy, Matthew J. "The Canadian Brewing Industry's Response to Prohibition, 1874–1920." *Brewery History*, no. 132 (Autumn 2009): 2–17.

———. "Under the Influence." *Walrus* (June 2013): 24–28.

Biggar, Henry Percival, ed. *The History of New France*. Vol. 1. Toronto: Champlain, 1907.

Bowering, Ian. *The Art and Mystery of Brewing in Ontario*. Burnstown, Ont.: General Store Publishing House, 1988.

Brent, Paul. *Lager Heads*. Toronto: HarperCollins Publishers, 2004.

Brock, Kathy Lenore. "Sacred Boundaries: Local Option Laws in Ontario." MA thesis, McMaster University, 1982.

Brumwell, Stephen. *Redcoats: The British Soldier and War in the Americas, 1755–1763*. Cambridge, UK: Cambridge University Press, 2006.

Burrows, Charles Acton. *The Annals of the Town of Guelph, 1827–1877*. Guelph, Ont.: Herald Steam Printing House, 1877.

Byers, Mary, and Margaret McBurney. *The Governor's Road: Early Buildings and Families from Mississauga to London*. Toronto: University of Toronto Press, 1982.

Campy, Lucille H. *The Scottish Pioneers of Upper Canada, 1784–1855*. Toronto: Natural Heritage Books, 2005.

Clarke, John. *Land, Power and Economics on the Frontier of Upper Canada*. Montreal: McGill–Queen's University Press, 2001.

Coupland, Douglas. *Souvenir of Canada*. Vancouver: Douglas & McIntyre, 2002.

Coutts, Ian. *Brew North*. Vancouver: Greystone, 2010.

Day, Shawn. "The Keepers Trade: Skills Attributes and the Pursuit of the Hotel Trade in Nineteenth Century Guelph." MA thesis, Guelph University, 2004.

Errington, Jane. *The Lion, the Eagle and Upper Canada*. 2nd ed. Montreal: McGill–Queen's University Press, 2012.

———. *Wives and Mothers, School Mistresses and Scullery Maids: Working Women in Upper Canada 1790–1840*. Montreal: McGill–Queen's University Press, 1995.

Fowke, Edith. *Traditional Singers and Songs from Ontario*. Don Mills, Ont.: Burns & MacEachern Limited, 1965.

Galbraith, John Kenneth. *The Scotch*. Toronto: Macmillan, 1985.

Gates, Steve. *The Breweries of Kingston & the St. Lawrence Valley*. Kingston: self-published, 2011.

Godfrey, William. *Pursuit of Profit and Preferment in Colonial North America*. Waterloo, Ont.: Wilfred Laurier Press, 1982.

Heron, Craig. *Booze: A Distilled History*. Toronto: Between the Lines, 2003.

Herrington, Walter S. *History of the County of Lennox and Addington*. Toronto: Macmillan, 1913.

Holman, Andrew C. *A Sense of Their Duty: Middle-Class Formation in Victorian Ontario Towns*. Montreal: McGill–Queen's University Press, 2000.

Hyde, Thomas. "Practical Notes on a Visit through American and Canadian Ale Breweries." *Journal of the Institute of Brewing* 13, no. 4 (July–August 1907): 357.

Isham, James. *Observations on Hudsons Bay, 1743 and Notes and Observations on a Voyage to Hudsons Bay*. Toronto: Champlain Society, 1949.

Jackson, Michael. *The World Guide to Beer*. London, England: Quarto Limited, 1977.

Jaenen, Cornelius J., ed. *The French Regime in the Upper Country of Canada during the Seventeenth Century*. Toronto: Champlain Society, 1996.

Mallack, Dan. "The Boys and Their Booze." *Canadian Historical Review* 86, no. 3 (September 2005): 411–52.

———. *Try to Control Yourself*. Vancouver: UBC Press, 2012.

McLeod, Alan. "Beer and Autonomy." In *Beer & Philosophy*. Edited by Steven Hales. Malden, MA: Wiley-Blackwell, 2007.

———. "A Good Beer Blog." 2003–14. http://beerblog.genx40.com.

Merritt, Richard, et al. *The Capital Years: Newark 1792–1796*. Toronto: Dundurn Press, 1991.

Morison, J.L. *British Supremacy & Canadian Self-Government 1839–1854*. Toronto: S.B. Gundy, 1919.

Osborne, B., and D. Swainson. *Kingston: Building on the Past*. Westport, Ont.: Butternut Press, 1988.

Patterson, William J. *Portland, My Home: An Illustrated History of Portland Township.* Portland, Ont.: Portland Township, 1994.

Peppin, John C. "Price-Fixing Agreements Under the Sherman Anti-Trust Law." *California Law Review* 28, no. 6 (September 1940): 667.

Perrie, Bill. *Craft Brewers of Ontario.* Toronto: WMI Books, 2006.

Phillips, Glen C. *On Tap: The Odyssey of Beer and Brewing in Victorian London-Middlesex.* Sarnia, Ont.: Cheshire Cat, 2000.

Pippin, Douglas James. "For Want of Provisions." PhD diss., Syracuse University, 2010.

Powers, J.M., and D. Duncan. "Temperance Hotels and Those 'Damned Cold Water Drinking Societies.'" *Oxford Symposium on Food and Cookery 1991: Public Eating, Proceedings.* London, UK: Prospect Books, 1991.

Preston, Richard A., ed. *Kingston Before the War of 1812.* Toronto: Champlain Society, 1959.

Pricket, Abacuk. *A Larger Discourse of the Same Voyage, 1625.* Toronto: University of Toronto. The Early and Modern English Language, Internet collection. Compiled by Professor C. Percy. http://homes.chass.utoronto.ca/~cpercy/hell/anthology/travel/Travel1625Pricket.htm.

Purdy, Al. *Beyond Remembering: The Collected Poems of Al Purdy.* Madeira Park, BC: Harbour Publishing, 2000.

Rich, E.E. ed. *Hudson's Bay Company, Copy-book of Letters 1680–1687.* Toronto: Champlain Society, 1948.

———. *Minutes of the Hudson's Bay Company, 1671–1674.* Toronto: Champlain Society, 1942.

Roberts, Julia. *In Mixed Company: Taverns and Public Life in Upper Canada.* Vancouver: University of British Columbia Press, 2009.

Rohmer, Richard. *E.P. Taylor: The Biography of Edward Plunket Taylor.* Toronto: McClelland and Stewart Limited, 1978.

Scadding, Henry. *Toronto of Old: Collections and Recollections Illustrative of the Early Settlement and Social Life of the Capital of Ontario.* Toronto: Adam, Stevenson & Company, 1873.

Schneider, Stephen. *Iced: The Story of Organized Crime in Canada.* Mississauga, Ont.: Wiley & Sons, 2009.

Sneath, Allen Winn. *Brewed in Canada.* Toronto: Dundurn Group, 2001.

St. John, Jordan. "St. John's Wort: Beery Musings and Amusing Beers." Self-published web log, 2010–13.

Strange Brew. Directed by Rick Moranis and Dave Thomas, 1983. Warner Home Video, DVD, 2002.

Talman, James, ed. *Loyalist Narratives from Upper Canada.* Toronto: Champlain Society, 1946.

Thompson, Scott, and Gary Genosko. *Punched Drink: Alcohol and Surveillance in the LCBO, 1927–1975*. Halifax, NS: Fernwood Publishing, 2009.

Thwaites, Reuben Gold, ed. *The Jesuit Relations and Allied Documents: Travels and Explorations of the Jesuit Missionaries in New France 1610–1791*. Cleveland, OH: Burrows Brothers, 1898.

Tulchinsky, Gerald, ed. *To Preserve & Defend: Essays on Kingston in the Nineteenth Century*. Montreal: McGill–Queen's University Press, 1976.

Wrong, George M., ed. *Sagard's Long Journey to the Country of the Hurons*. Toronto: Champlain Society, 1939.

The Yeas and Nays Polled in the Dunkin Act Campaign in Toronto. Toronto: Leader Steam Job Printing Office, 1877.

INDEX

ABOUT THE AUTHORS

ALAN MCLEOD has been writing about beer for
more than a decade. He lives with his family
in Kingston, Ontario, where he practices law.
Through his work, he has explored the heritage
and history of his corner of Ontario. Alan is
one of the founders of the Albany Ale Project, a
collaboration that explores the roots of Ontario's
New York Loyalist traditions through the lens of a
beer glass.

JORDAN ST. JOHN is Canada's only nationally
syndicated beer columnist. He is the author, with
Mark Murphy, of *How to Make Your Own Brewskis:
The Go-to Guide for Craft Brew Enthusiasts*. He holds
the rank of Certified Cicerone and periodically
brews beer with breweries around Ontario. His
family has been in Ontario since 1817 and has its
own cemetery in Uxbridge.

Visit us at
www.historypress.net

· ·

This title is also available as an e-book